Icons and Aliens

From Alien to Icon in a Half-Century

When completed in 1937, the Golden Gate Bridge was castigated by one
critic as an "eye-sore to those now living and a betrayal of future gener-
ations . . . , [a work that] would certainly mar if not utterly destroy the
natural charm of a harbor famed throughout the world." Golden Gate Bridge
was then an "alien"; it simply didn't fit with the harbor, the "icon." Fifty
years later, however, the Golden Gate had become an icon, no less celebrated
by San Franciscans than the Eiffel Tower is by Parisians. An estimated
350,000 revelers jammed its span during an early morning walk that com-
menced the celebration of its fiftieth anniversary.

Icons and Aliens

Law, Aesthetics, and Environmental Change

John J. Costonis

With a Foreword by Allan B. Jacobs

University of Illinois Urbana and Chicago

Publication of this book was made possible in part by a grant from the Graham Foundation for Advanced Studies in the Fine Arts.

This book is printed on acid-free paper.

Contents

Foreword

The early 1970s brought a rush of new apartment proposals to the expensive, chic Russian Hill neighborhood of San Francisco, one of those very special districts that everyone seems to know of and that contributes markedly to the city's image, like it or not. Russian Hill is where—heaven help us—the "little cable cars climb halfway to the stars."

The city's planning department was ready, or thought it was. It had figured out, to the community's general agreement, what made the hill neighborhood special and what ought to be saved and respected in any new development. The specialness was in the dramatic public and private views of San Francisco Bay and of the rest of the city from the hill, the low, old, fine residential houses and small apartments that hugged the hill, and the generally widely spaced, slender high-rise apartments that accented the hill form. There were widely distributed and understood guidelines for new development. They included minimum spacing between any new, tall towers, maximum dimensions to ensure slenderness, and a listing of specific architectural characteristics as well as buildings that were important, if not always historic—what John Costonis would call the "icons" of Russian Hill. The zoning had not been changed—it included some areas that permitted the highest residential densities in the country at 700 dwelling units to the acre, and there were no height limits—but that was sure to come. The planning department had also made clear which were the inappropriate buildings—like bulky high rises and those with blank walls along the streets—so that these "alien" types would not be repeated.

Thus the maintenance of the quality of Russian Hill, including its most important landmark buildings, was pretty much assured, but only until the next major development proposal. Measurably (with a ruler), the first proposal by a very influential, very well financed, very well legally represented developer did not meet the guidelines or standards, call them what you will. Interestingly, the same people who earlier had agreed to the guidelines, in this case the planning commission and the mayor, somehow concluded that the requirements had been met and the proposal, despite vigorous opposition from public and staff at a lively open hearing, was approved.

To be sure, there were no historic buildings involved, no icons, but there easily could have been; indeed, I could cite a lot of examples where there have been. San Francisco, and just about every city I can think of, has lost many important buildings, sometimes whole areas. In the Russian Hill case, the entire district, its physical, developmental character, is the icon.

Of course, things could have worked the other way; that is, the proposal could have met the guidelines and still been turned down. We've all seen that happen, or at least we feel that's what has happened. Then, too, there were a number of cases of buildings that clearly—clearly to me, at least—did not meet the guidelines for designation as historic buildings but, in the heat of controversy, were found so by the landmarks officials, the planning commissions, and the legislative bodies. The possible variations of inputs and outcomes are endless. What might we learn from all this? One lesson seems clear in this business of city-keeping-and-building: If something is really important, don't leave it to chance, and don't leave it to someone else's discretion or interpretation, particularly when that discretion/interpretation will be exercised in the midst of developmental power struggles. Don't leave things, as today's city planning fraternity would have it, to "the process." The San Francisco experience, as well as so many examples that Costonis gives us in this volume, shows overwhelmingly that decisions made as part of power confrontations will be made in favor of the side with the most power, and the so-called guidelines or criteria that are ostensibly the basis for decisions will be bent and twisted, often out of possible recognition, during the process. Moreover, my experience is that although neighborhood groups or the focused, nonprivate interest coalitions, such as those concerned with saving historic structures, may gain ascendancy from time to time or even for a few years, over any extended period in the United States those groups with the most money or the best financing have the most power and therefore win. I'm speaking of the big development interests, not the neighborhood or conservation groups, not the public planners, and not the small developers (one group the public planners can regularly beat up).

It is for just such reasons, of course, that people have long since determined that their communities should have plans to achieve what they want their cities and towns to be—and that includes keeping what is good and meaningful to the collective memory as well as keeping out what is known to be unwanted. In a city like San Francisco, with its extraordinarily strong pressures for development, not unlike New York and many other cities, I relearned that lesson: have a plan; have it as soon as possible; the more important the subject, the more specific and less open to interpretation the plan and implementing centers should be. A series of questions arise, however, that make it much easier to call for a plan

than to formulate and carry one out. How important is the design of a city? Who will determine good design? How important are the existing, sometimes old, felt-to-be historic buildings that we would like to preserve, assuming we can determine which ones are to be chosen? And what are the rights and responsibilities of those who own the icons?

Many communities in the United States have never had to, or wanted to, deal with these questions of what of the past should be kept or what constitutes good, desirable design for the future. I think it is fair to say, however, that increasingly this is not the case; that preservation, if not the design of new buildings, is a major consideration in our cities. For a whole series of reasons people are aware of the past and the built environments that represent earlier periods, and they want to keep these structures. Indeed, there is even argument in some places, unfounded I believe, that the pendulum has shifted in the space of perhaps only fifteen years from a state where it was chancy, at best, to save anything, no matter how good and beloved, to one where it is difficult to replace anything. While most people agree that almost every community has lost extraordinarily fine buildings and that many of the best are still in jeopardy and should be saved, increasingly, with the ascendancy of the preservation movement, there is argument that less than worthy buildings are being saved and that historic preservation is being used as an antidevelopment, antichange, antigrowth tool. It is into this controversy that this book takes us.

John Costonis is no newcomer to preservation-development wars. He was involved in the early 1970s in a noble attempt to save Chicago's Old Stock Exchange and in many others (more successful too, thank goodness) since. As an environmentally sensitive, caring activist, he was compelled to think of positive solutions to the problem of the loss of community icons. Understandably, it is not enough to be called into the breech, usually at the eleventh hour, to save these structures via the courts. *Space Adrift*, a full-fledged rationale for the use of the transfer of development rights (TDR), primarily (at that time) directed to saving historic buildings through the permitted sale of the unused development potential on such sites for use elsewhere, was the most noteworthy result. TDRs have since become a relatively standard legal tool in many parts of the world not only to save buildings but to help direct development to where it is most wanted. In planner's jargon, the TDR is a tool for helping to carry out plans.

In the period since those early legal preservation battles, we have seen a concern for continuity develop and take an important place in people's awareness and sense of community values. Official commissions and boards responsible for the custody of community patrimony are common and often come with some real powers as well as fiscal incentives that can help property owners keep older, fine

structures. The powers often go beyond individual buildings and may extend to large areas deemed important in their entirety and to what is necessary for new buildings to fit with them. Interestingly, these commissions and boards are often separate from the official local planning agencies. When this is so, it is almost inevitable that they will at times conflict with each other. Regardless, there are now strong official advocates for preservation in many, many communities. It should not come as a surprise that they would, like others before them, run into sticky questions about what is and is not worthy, either to be retained or to fit in with what already exists. To some considerable extent the issues lie between aesthetics and law. This is Costonis's concern.

The early Chicago preservation conflicts behind him, John Costonis has remained enthralled with the law and aesthetics. I suspect that his concern comes from two intense (if not consuming) passions that at times conflict with each other: his own sensitivity to quality architecture and art, an inheritance from a working-class, ethnic childhood and from much older, spiritual values originating in Greece and Italy, still the measuring rod for so much that we consider good and right in the built environment; and the law and people's rights, with an emphasis on the rights of the underdog. The part of his work with which I am most familiar involves his discussions with architects and urban designers. Over at least a ten-year period he has met with countless designers, basically to find out their views about the law and aesthetics: What, if anything, do they expect of the law? What should be the role of the law in preservation or in achieving good design? Should the law even speak to this question or should it steer clear? Do laws really constrain good design? creativity? And on and on.

This is not always easy work. I recall a particular evening in San Francisco with Marc Goldstein, John Kriken, and Tom Aidala. We all knew each other well, save Costonis. What was most fascinating to me is that there were at least four different languages being spoken that night, all using English as the medium of conversation. I wondered how he could possibly understand what was being said, since I did not think I did, and whether any of it was coherent, which it surely was not to my ears. Costonis would ask a question and then listen while the rest of us babbled. After fifteen or twenty minutes he'd ask another question and we'd start in again. Later, he said he was getting used to listening to different languages; he was trying to get at what was important. Over the years, John Costonis has listened to a lot of other people, including the late Donald Appleyard, who perhaps was most coherent in helping to bring to the discussion a sense of the centrality of community values in relation to the built urban environment.

Of course, Costonis has gone further than others. He is a lawyer, after all, and so he has gone back into what the law has had to say

over the years and, more to the point, what legal precedent has been. And he has followed the cases, particularly those in New York City, where he was active, tangentially to his educational role at New York University School of Law. All of this he now shares with us in a dialogue that is at once historic, argumentative, sometimes humorous, full of examples of preservation battles, and properly replete with admonitions of "on the one hand this, but on the other hand that." He warns us about arbitrariness in our concern for keeping what is considered good and keeping out what is bad and of using the preservation mantle to do things never intended for it, such as zoning. What the law has given or upheld, the law can take away, which he reminds us more than once.

Ultimately, John Costonis gets back, I think, to an urban physical planner's point of view, although he never says it in so many words, which is where this Foreword began. If something is important, plan for it as early and as specifically as possible and then do it with the use of laws and with direct public action. Don't wait until the battles start; work instead to prevent them. I have never known why it was not possible for a community to set standards for what it wants, including what it wants to keep, as well as the critical characteristics of what it wants to look like and feel like, stating the reasons why, and then incorporate those findings and aspirations into a firm, legally binding plan. In this vein, it behooves us to go on record to say specifically what buildings and areas are icons, not to be fooled with. We must not make these decisions as we go along, in some haphazard and too often greed-inspired way. That is where John Costonis takes us. It is an important trip.

Allan B. Jacobs

Preface

Zucchini on Park Avenue. East Side buildings on Manhattan's West Side. Billboards along a scenic Arizona highway. Sodium vapor lamps in downtown Bronxville. Porno theaters adjoining a Detroit residential neighborhood. Day-Glo sculptures on a Scarsdale lawn. An International Style tower atop the Beaux Arts Grand Central Terminal. An office complex soaring above the nation's Capitol. A Con Ed pumping station on Storm King Mountain. Such pairings are the subject of this volume, which probes why they evoke outrage, why the outraged seek the protection of the legal system to prevent the pairings, and what the law can—and cannot do—in response.

Icons and Aliens was prompted by my fascination with the various and confused usages of the term "aesthetics" when employed to explain or justify the use of law to control the appearance of the visual environment. "Aesthetics" translates into "beauty" in popular understanding, no less than in the reasoning of a number of influential treatise writers, judges, and publicists.[1] The mission of legal aesthetics under this view is to create and maintain a beautiful environment. While contending viewpoints can also be gleaned from aesthetics commentary and legislation, the aesthetics/beauty linkage continues to shape our thinking, talking, lobbying, and litigating about what we experience as the loss or contamination of a familiar, reassuring environment.

Beauty is off the mark as the force behind aesthetics laws, in my view. In its place I propose to substitute our individual and social needs for stability and reassurance in the face of environmental changes that we perceive as threats to these values. Traditionally recognized values, such as maintenance of property values or protection of public health, cannot be ignored, of course. But the mission of preserving psychological stability and reassurance differentiates legal aesthetics, in my preferred conception of the venture, from conventional land use theory, which either ignores the mission or folds it into more commonplace concerns.

The environment, as viewed here, is an assemblage of natural and built features, many of which have become rich in symbolic import. The "icons" are features invested with values that confirm our sense of order and identity. The "aliens" threaten the icons and hence our

investment in the icons' values. These threats may take the form of extinction, as when landmark buildings are demolished to make way for office towers, or contamination, as when billboards are strewn along scenic vistas.

What is often described as the "physical environment" is also a stage featuring explosive tensions between our love of the familiar and our fear of the unknown or uncertain. So viewed, the symbolic environment is not unlike religion, language, or popular culture, where change also disorients and destabilizes. Unlike these anchors of our identity, however, the symbolic environment inhabits a physical host—mountains, wildernesses, bays, buildings, and urban settings. Legal aesthetics' distinguishing mission is preservation of symbol through preservation of host. By preserving icons, legal aesthetics safeguards what Donald Appleyard aptly termed our "sense of self in a place."[2]

This first of the volume's two principal positions is introduced in chapter 1 and detailed in chapters 3 and 4. Secondarily addressed in these chapters are various theoretical and practical inadequacies of the beauty-based rationale for legal aesthetics. Ignoring the rationale's stubborn hold on popular and professional thought would leave the tale incomplete. Contrasting the rationale with its stability-based alternative illuminates as well the relationship between the environment as symbol and our disposition to invest our most deeply held values in the environment's icons.

The role of the legal system as protector of icons is the volume's second principal concern and is engaged in chapters 1, 2, and 4. The questions posed under this heading consider whether the law *can* provide this protection and whether it *should* do so if the consequence of its action is to override competing legal and social values of a nonaesthetics nature. This inquiry, again, takes into account differences between the stability- and beauty-based rationales for legal aesthetics.

By stating the two questions in this manner, I seek deliberately to surface the law's limitations no less than its capabilities. My purpose, however, is not to dishonor legal aesthetics. On the contrary, I seek to strengthen the case for legal aesthetics by redefining its social and legal foundations more cogently than the courts have succeeded in doing to date. In the course of this effort, however, I have become persuaded that legal aesthetics presently risks the loss of its hard-earned credibility because these questions are not being asked.

The unhappy truth is that improperly conceived aesthetics initiatives can father results distressingly at variance with their stated goals, as chapter 2 details. These results have not gone unnoticed by academic and professional observers, many of whom now dismiss legal aesthetics as an unfortunate experiment that should be terminated forthwith. My view of the matter differs. While the reported

distortions have indeed occurred, a far larger number of aesthetics initiatives have succeeded in accommodating the tension between change and stability while treating fairly the constituents of both. There seems little basis, therefore, for throwing the baby out with the bathwater, as these critics urge. But—and this is a big but—it is equally clear that legal aesthetics is a more complicated and risky business than was understood when the United States Supreme Court speeded it along its way in *Berman v. Parker*, the Court's momentous pro-aesthetics opinion rendered in 1954.[3] The challenge, as I see it, is to introduce into legal aesthetics the mid-course corrections indicated by post-*Berman* experience, an effort that necessitates the inquiry proposed above.

Once the stability-for-beauty substitution is made, two impediments to effective legal management of change in the symbolic environment become clear. One is the venture's open-ended nature. It is impossible to predict which of the environment's countless features will become icons and which will be aliens. Teamwork between the social and legal systems is necessary, both to validate that this or that feature merits legal protection as an icon and to design an aesthetics regime that will, in fact, protect it from marauding aliens. Moreover, some of the values that we associate with icons are not amenable to regulation by these regimes because the values do not "translate" into physical form, the sole focus of aesthetics regulation. Illustrative is New York City's Upper East Side, popularly known as the Silk Stocking District because of its associations with the rich and famous. Clearly an icon in the community mind, the district as a whole lacks a coherent physical form affording a basis for the equivalently coherent set of design standards required to evaluate proposals for new development there.[4]

The second impediment, intimated by the first, is the ease with which aesthetics regimes may be diverted to ends remote from their ostensible goals. Because stability and reassurance are such open-ended, emotionally laden values, lawmakers experience difficulty in confining these regimes within administrable standards. Administrators find themselves buffeted by contending constituencies, each of which comes equipped with its own agenda. And judges must wrestle with knotty problems posed by the conformance of these regimes with such constitutional values as artistic freedom, private property, and properly confined delegations of legislative power to administrative agencies.

Why these obligations? Because legal aesthetics utilizes the power of the state to enforce its regimes detailing whether or not change may occur and, if so, in what form. Viewed from this angle, the aesthetics controversies recorded here are, at base, contests for control of this power. But state-sanctioned power must be allocated on a principled basis in a system, such as ours, that is predicated on the rule of law. The responsibility falls to legal institutions to ensure

that the rule of law is not ignored in the effort to assuage the anxiety we all experience when confronted with environmental change. Suggestions for achieving this delicate balance are detailed in chapter 4.

In the Epilogue I introduce a question that merits a successor volume: Are we overdoing our commitment to icons? Reassurance and stability are important, even indispensable in our lives, but so too are innovation and autonomy. Aliens may be the villains from the first perspective, but they are the heroes from the second. A portrayal of legal aesthetics cannot itself make the choice between familiarity and innovation. That is an issue for our culture at large. But it can afford a clearer vision of the choice's consequences for the law and, ultimately, for American society itself.

Icons and Aliens is not a treatise on the law of aesthetics; readers seeking comprehensive compilations of statutes, judicial decisions, and the like must look elsewhere. Nor is this volume a study of aesthetics, as that term is conventionally understood. Rather, I seek to bring to the surface the conflicts besetting these unlikely partners and to suggest pathways leading to greater harmony between the two.

The frequent selection of examples from the historic preservation field merits comment, lest it be assumed that I believe that landmarks and historic districts are the environment's sole icons. Obviously I do not. Preservation examples have been disproportionately featured for another reason: namely, in no field is the opposition between icon and alien so graphic. Moreover, few, if any, of legal aesthetics' other charges have been the subject of such extensive judicial examination. Historic preservation examples are not intended to confine inquiry but to serve as a bridge to the volume's broader inquiry into the linkages among ourselves, our symbolic environment, and the law.

I have borrowed generously from cartoonists and photographers in portraying the ideas developed on the following pages because many of these ideas translate more effectively visually than verbally. In the course of selecting the graphics, moreover, I discovered that the juxtaposition of a cartoon with a photograph dealing with the same idea enlarges our understanding of the idea's humorous and distressing aspects. The humor of the cartoonist, it often turns out, is rooted in tension and distress, and the latter appear unvarnished in the juxtaposed photograph. This seeming contradiction confirms my sense that our apprehension of environmental change is, at root, a deadly serious business.

Many have been the individuals and institutions assisting me in this venture. Michael Kwartler, Karen Franck, and the late Kevin Lynch and Donald Appleyard have been wise and patient counselors. The *Michigan Law Review* suffered my initial effort to order my thoughts on the topic in a format featuring exhaustive legal documentation supporting the arguments advanced here.[5] The National

Endowment for the Arts and the New York University and Vanderbilt University Schools of Law also supported the effort, both financially and through the personal encouragement of Charles Zucker, Dean Norman Redlich, and Provost Charles A. Kiesler. Diane Maddex assisted me in identifying and securing many of the cartoons and photographs. Michele Jennings, Sue Ann Blackburn, and Joyce Hilley performed secretarial miracles throughout the entire editorial process.

My wife, Maureen, and my children, Terri, John, and Sarah, merit the choicest plaudits of all for their patience and love throughout the years I devoted to this very personal odyssey.

John J. Costonis

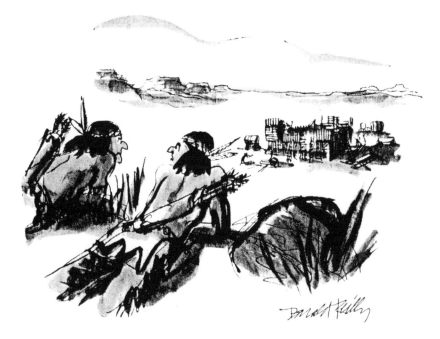

"Another monstrosity."

Change in the Environment

Environmental change is often painful. How we experience particular changes, moreover, is a function of our individual and cultural backgrounds. Behind the humor in this cartoon is the pathos of powerlessness and cultural disfranchisement. There is no architectural or preservation commission to which the Indian warriors can appeal to block the desecration of their tribal lands by the United States Cavalry's "monstrosity." Times have changed, of course, and the nation's legal system has devised various regulatory programs intended to moderate the pathos of change. How well they have succeeded is the subject of this volume.

Aesthetics in the Museum and in the Courthouse

Ideas have consequences, as Dostoyevski warned. The most problematic of these are often the least intended, he might have added. This volume examines the consequences of the idea of aesthetics as it has merged with the idea of law in public programs designed to control the visual appearance of America's cities and natural environment. The story is intriguing, frustrating, and, at this telling, incomplete.

Aesthetics and law are an odd couple, rather like spouses who come to their union from different worlds. Their merger is novel, lacking the benefit of clergy or of experience to counsel them in resolving their post-honeymoon conflicts. Nor have the admiring relatives who pushed for the marriage clearly grasped these ideas or their potential for conflict. Aspirational and abstract, aesthetics and law are elusive in themselves and mercurial when joined together.

I write as a marriage counselor at a time when the honeymoon has ended and the hard work of making the marriage work lies ahead. Unlike most marriage counselors, however, I cannot claim objectivity. I *want* this marriage to work despite its potential impediments, chief among which is the failure of spouses and sponsors alike to appreciate the transformation that aesthetics experiences as it moves from the museum to the courthouse.

Beauty and creativity are the concerns evoked by aesthetics in the museum, its premarital abode. What is beauty? What in the individual human soul or in a culture accounts for its creation? Debated for centuries, these questions continue to engage philosophers, artists, and poets. Mistakenly, the same concerns have shaped how many of us think about aesthetics in the courthouse. There, however, aesthetics' referents are stability and power. Cherished features of our environment are preserved not because they are "beautiful" but because they reassure us by preserving, in turn, our emotional stability in a world paced by frightening change. Features serving this function are the "icons" of this volume's title. Nor is aesthetics a synonym for unbounded creativity. Quite the opposite, it justi-

fies the exercise of state power to prevent an icon's contamination or destruction. New developments posing such threats are this volume's "aliens."

Although the law/aesthetics union faces other impediments, the courthouse/museum confusion merits a volume of its own, in my judgment. Let us review two real-life "aesthetics" controversies to see if I have chosen wisely.

East Side, West Side, All Around the Town (and Nation)

Keeping Zucchini Out of Park Avenue

KILLER VEGETABLES INVADE PARK AVENUE! So the March 1984 headlines of New York City's dailies might have read in describing the panic following Kyu-Sung Choi's decision to open a twenty-four-hour delicatessen on the northeast corner of Park Avenue and Seventy-fifth Street, where the Korean college graduate intended to sell vegetables along with the usual deli fare. Why the panic? Because Park Avenue and Seventy-fifth Street is not just any location: it is *Park Avenue*, after all. It is also within the 60-block, 1,000-building Upper East Side Historic District established prior to the deli flap. And it is part of a 30-block strip of Park Avenue declared off-limits to nonresidential uses by a 1961 amendment to the city's zoning code. But Choi's deli was exempted under a grandfather clause in the ban: commercial tenants had occupied the site prior to 1961, and Choi's immediate predecessor had been a florist.

Seated in the library of her apartment on the other side of Park Avenue, Shirley Bernstein, leader of the neighborhood opposition, explained: "Do the residents of Park Avenue want to look out the window at *vegetables*? They certainly do not." In her view and that of her neighbors, to whom Park Avenue is "an oasis of peace and safety in a crazy world," the deli would destroy neighborhood character, decimate property values, and attract criminals and rats, along with "a generally undesirable type of person that we are not accustomed to." When asked what kind of food store would be appropriate, Bernstein responded: "We do not want a food store of any kind. Flowers might be all right. Or chocolates. Yes, Swiss or Belgian chocolates."[1]

To repel the dreaded vegetables, the neighborhood fielded a powerful army. Its standard-bearers were Manhattan's borough president, whose parents lived in Mrs. Bernstein's building, and the state assemblyman from the East Side, who was said to be considering legislation "to insure that this never happens again."[2] Also enlisted was the municipal bureaucracy. The landmarks commission complained that Choi had substituted a glass door for a wooden one without its permission. The city's buildings department added that Choi's use of the deli's basement for storage space was a zoning

violation. Poring over the zoning, building, and landmarks codes as assiduously as they crawled about the deli's unfinished premises were members of various community groups. Prominent among them was the Friends of the East Side Historic Districts, which boasted 120 "monitors" dedicated to ferreting out possible violations of the landmarks code. A war chest was also collected for a lawsuit, should all else fail.

Had the media not gotten involved, the deli might never have opened. But the spectacle of a posh neighborhood cringing before an onslaught of okra and zucchini caught the eye of cartoonists, editorialists, and television personalities. So too did the story's delightful ironies. One concerned the business the deli replaced, nostalgically described by one neighbor as that "nice little flowershop."[3] But "nice" it was not. It actually had been a front for a drug dealer jailed two years earlier for selling heroin and bombing his competitor's "flowershop" five blocks away. Such goings-on prompted Dick Cavett to quip that Mr. Choi was "only trying to upgrade the neighborhood."[4] There was also the letter published in the *Times's* Letters to the Editor column. Its writer, a Park Avenue resident during the 1920s, recalled that the deli site was once "occupied by a very nice grocery store, which displayed its wares in the window" and wondered, "So what's all the fuss about now?"[5]

Icons, Aliens, and Associational Dissonance

Opposition between icon (Park Avenue) and alien (deli) receives humorous treatment in this portrayal of the Park Avenue matron's shock at their dissonance . . . as she experiences the duo. Poodles, mink coats, limousines, and "Le Ultimate" clash with the plebeian deli across the street. But beware. Such clashes are no laughing matter when it is *our* icon and *our* feelings that are assaulted by the dissonance of a feared alien.

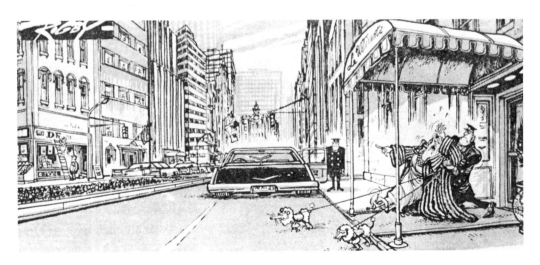

"Eeeek! I knew the world was going completely mad, but a DELI on Park Avenue?!"

The dispute ended in compromise. Stung by the media's acid commentary, lawmakers deftly covered their tracks. One even held a press conference at the deli, praising Choi and lambasting politicians so craven as to subvert this splendid example of American Free Enterprise. Choi proved flexible as well. True, he resisted Cavett's suggestion to call the place Designer Veggies and to ask "Calvin Klein or Yves St. Laurent to get up becoming little sweaters for the produce."[6] But he titled his deli Park 75 Gourmet Foods, and he saw to it that his vegetables stayed *inside* the store. And very high-pedigree vegetables they were: endive from Belgium, peppers from the Netherlands, and asparagus from France. Nearby were caviar and imported chocolates, the latter taking up one-fourth of the store.

At the deli's opening, Choi confided to a reporter that he would give away small ribbon-wrapped boxes of chocolates to his first 375 customers. "Imported," he grinned, holding up one of the boxes of Côte d'Or Bouchées. "Belgian."[7]

Keeping "East Side Buildings" Out of the West Side

"Perhaps the most agonizing landmark fight in Manhattan in some years,"[8] opined the *New York Times* over the second battle, which had flared up ten blocks to the west and four years earlier. The *casus belli* this time was the future of the Isaac I. Rice Mansion and its site at Riverside Drive and Eighty-ninth Street. An eclectic blend of Beaux Arts and Neo-Georgian styles designed by the carriage-trade architects Herts and Tallant, the mansion was built in 1901 for Isaac I. Rice, a railroad and electric car magnate. Originally surrounded by the mansions of other fin de siècle plutocrats, it alone survives, its neighbors replaced with fifteen-story apartment houses and four-story rowhouses.

In 1954, the yeshiva Chofetz Chaim acquired the mansion for use as a religious school for Jewish children. Unlike Rice, the yeshiva was not wealthy. "We always come with a deficit,"[9] Rabbi Feigelstock, the yeshiva's dean, grumbled after the battle erupted in 1980. At issue was the yeshiva's proposed $1.5 to $2 million sale of the mansion to a developer who intended to replace it with a thirty-story tower-plaza building that would include modern school facilities for the yeshiva.

The battle lines formed quickly as rumors of the impending sale circulated. On one side were the yeshiva, large segments of the city's Orthodox Jewish community, the developer, and advocates of increased residential construction to alleviate Manhattan's grave housing shortage. The opposition was championed by Community Planning Board No. 7, the dominant West Side neighborhood organization. It filled its ranks with irate West Siders and formed alliances with celebrities, Jackie Onassis and Itzhak Perlman among them, and with such gold-plate citywide groups as the Municipal Art Society and

Icons and Aliens

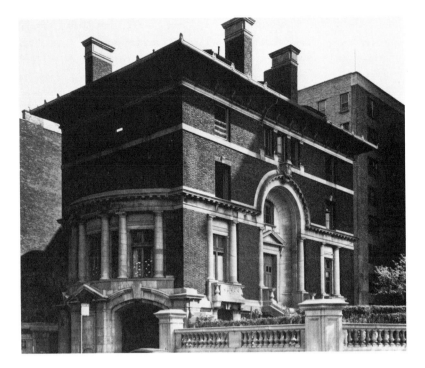

Isaac I. Rice Mansion

Does this mansion merit designation in law as a landmark? Or was the law's shield invited instead to keep "East Side buildings" out of the West Side, thereby preserving unchanged a way of life cherished by many West Siders?

the Citizens Union. Ultimately, it was favored with a pro-designation column from the *Times* architecture critic.

Under the city's landmarks code, designations require the approval of lawmakers and administrators or, in the city's case, of its Board of Estimate and its Landmarks Preservation Commission. Legally defined, the issue for both was whether the mansion possessed the "special character" or "special historical or aesthetic interest or value" called for by the code. But a richer assessment was offered by a journalist who, comparing the dispute to an onion, observed: "Peel away a layer . . . and all you find are more layers."[10] One layer, certainly, was legal: Did the mansion meet the standards set forth in the code's Delphic language? For the Citizens Union's spokesman, the answer could not have been clearer. "The Mansion," he intoned, "is a landmark, was a landmark, it always will be a landmark." Rabbi Feigelstock was perplexed. "By me, Isaac Rice is not anybody," he sulked. "We suddenly heard his name when this whole thing came up."[11]

Perhaps the arts groups genuinely believed that the mansion was a landmark and merited designation for this reason alone. But Board

No. 7 used the proceedings to launch a preemptive strike against the thirty-story tower, which it viewed as a harbinger of unwanted changes for the West Side. The new building, it worried, would block existing views and eliminate the open space around the free-standing mansion. More important, its profile as a slender tower rising from a plaza below would project an image of a life-style that West Siders found repugnant. The last objection surfaced in the board's earlier protest against a similar tower-plaza high rise proposed as a replacement for the nearby All Angels' Church. With equal fervor the board decried the invasion of the West Side by "East Side buildings," advising that "if you want to live in a solid, low-rise, low-key, family-type building, you have to go to the West Side and we want to keep that alternative intact."[12]

A bit of zoning history explains the board's linkage of tower-plaza buildings with the East Side and of "low-rise, low-key, family-type" buildings with the West Side. The city's zoning code was modified in 1961 to discourage squat buildings uniformly set out to the street line—until then, the prevalent building format. Desired instead were towers set back from the street by plazas, an alternative that would encourage architectural diversity and allow light and air to flood in at street level. The East Side real estate market was then booming, and developers demolished scores of the squat, pre-1961 code buildings in the rush to build tower-plaza high rises. The established family unit, a disappearing species on the East Side, became a dwindling share of the market. Its place was taken by lawyers, advertising executives, teachers, and other young professionals who flocked to the efficiency and one-bedroom apartments that filled the towers and who gamboled in the bars, boutiques, and quiche-and-Perrier ambience portrayed in *Looking for Mr. Goodbar* and other films of the period.

Snug in their comfortably shabby buildings and family-centered life on the other side of town, West Siders sniffed at their neighbors to the east. Over time, however, telltale signs of East Side–ism began

Architecture as Social Imagery: East and West Side Buildings

The view from Third Avenue and Sixtieth Street looking north (opposite page, top) features a number of East Side buildings, which, as the zoning schematic reflects, utilize the tower-plaza format introduced in New York City's 1961 zoning code. These buildings are slender high rises set back by plazas that break the street wall. Contrasting with them are the West Side buildings featured in the photograph taken from West End Avenue and Eighty-first Street looking north (opposite page, bottom). Squatter structures flush to the street line, they afford the uniform street walls and 1920s feel that define the West Side's visual character. The mansion battle demonstrates how, in a particular neighborhood's perception, differences in physical geometry can become linked with fear over imminent changes in social geometry.

Icons and Aliens

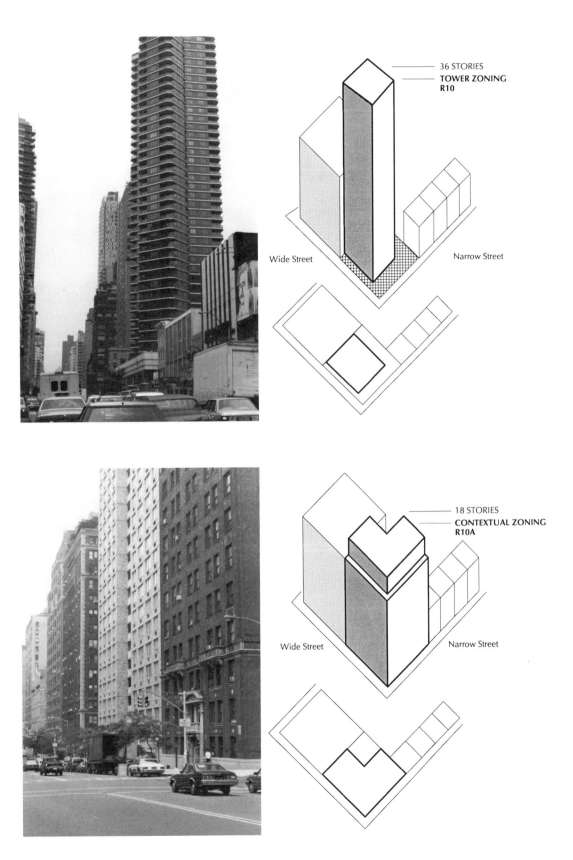

36 STORIES
**TOWER ZONING
R10**

Wide Street

Narrow Street

18 STORIES
**CONTEXTUAL ZONING
R10A**

Wide Street

Narrow Street

Museum and Courthouse Aesthetics

to appear. A boutique here, a singles bar there, or the overnight conversion of a mom-and-pop grocery store into a high-tech emporium with the gourmet appeal of Choi's reborn deli. Fears of spreading contagion intensified with the 1979 unveiling of the tower-plaza building proposed for the All Angels' site. To avoid all-out war, however, the developer compromised, substituting a bulky, twenty-story, brick-faced building that filled its lot and featured concrete stringcourses replicating the tripartite division and cornices of the West Side's older buildings. The revised design was a "mistake," he shrugged; but he allowed that "if they want a building to look like the buildings of the past, I'll give it to them." Board No. 7 was tickled pink, praising the revision as "a return to the 1920's."[13]

But in its dispute the yeshiva held fast, fuming that it was the victim of what later came to be called "landmarking by ambush." The proposed designation, Rabbi Feigelstock insisted, was nothing more than a power play to achieve elitist, grossly selfish goals. Scorned in particular were the view-blockage objection and the West Siders' readiness "to place bricks and stones above our children." Hostility to Orthodox Jewish religious and family life was also cited, one rabbi proclaiming: "A vote against the Yeshiva is literally a vote against the Jewish religious community on the West Side."[14]

The Board of Estimate was aggressively lobbied by powerful supporters from both sides. It split sharply in its vote; and its members accompanied their votes with delicately worded justifications. The audience sat riveted in their seats: one group wearing insignia imprinted with a sketch of the mansion; another, mostly Hasidic Jews, displaying Torah-inscribed escutcheons. An uneasy board ultimately endorsed the landmarks commission's recommendation favoring the designation. In its summary of the controversy, the *Times* concluded: ". . . virtually lost in the turmoil was a discussion of the architectural quality of the Rice Mansion—lost almost as much as Isaac I. Rice himself."[15]

The Case for Coherence

Featured in both Manhattan controversies, as well as in countless others elsewhere, is the premise that law can and should command when the visual appearance of America's cities and natural environment is at stake. So common is this premise, in fact, that modern observers seldom note it at all. But the premise raises a set of troublesome issues when joined with the widely held assumption that the aesthetics of the museum should govern in the courthouse as well.

The legal impulse is abstract and impersonal. It speaks through constitutions, codes, and rules. The aesthetics impulse is concrete and passionate. Its work is the Grand Central Terminal, *Swan Lake*,

Icons and Aliens

and *The Grapes of Wrath*. Language is the law's medium, tedious strings of caveats and codicils. The aesthetics impulse springs to life in movement, stone, color, and, yes, words, but how differently Yeats reads than the National Environmental Policy Act.

Law constrains and, when necessary, coerces. It is impersonal, the work of legislatures, courts, and administrative boards. It addresses the worst of our instincts, striving to fix a floor for their expression.

Aesthetics liberates. It takes chances. Aesthetics expression is individual, perhaps the most personal expression we know. It seeks to give flight to our creative fancies, not to censor the beast within. Aesthetics by committee is no less shocking than the coercion of individual or social behavior in its name.

Law canonizes objectivity, certainty, and reason. It is the left side of the brain. Aesthetics is the right. It is subjective, experimental, and intuitive. With feeling and myth as its muses, it delights in discerning the novel in the familiar and in tweaking the obsession for order that drives the legal mind.

Law knows nothing about beauty. It can set speed limits or require that contracts be in writing, but it can neither create beauty nor issue ukases guaranteeing that others will do so. The Constitution contains no recipe for beauty. Nor can law borrow one from the neighbors next door in the same way, for example, that it gets its standards for safe drinking water from medical science.

Aesthetics, too, has its problems in listing beauty's ingredients. Alexander Baumgartner, who coined the term back in the eighteenth century, defined aesthetics as the "science of sensory cognition."[16] But Freud, among others, was skeptical, retorting that because the "science of aesthetics . . . has been unable to give any explanation of the nature and origin of beauty, . . . [its] lack of success [has been] concealed beneath a flood of resounding and empty words."[17]

We needn't be distressed that aesthetics cannot disclose beauty's secrets. Vigorous debate stimulates artist and audience to see in fresher, more probing ways. Confusion in the legal realm, however, *is* distressing. The rule of law, as we Americans understand it, demands that public programs that coerce our behavior or distribute tax benefits and other boons be coherent in their ends and means. Aesthetics programs, of course, do both. But if the law is beauty-blind, how can it coherently fashion and administer these programs?

Incoherent public programs leave citizens guessing what it is that the law expects of them and whether these programs merit their support in the first place. Such programs also generate unfortunate responses from the bureaucrats assigned to administer them. Timid bureaucrats tend to sit on their hands when they have a confusing mandate; aggressive ones find themselves tempted to shape policy on their own rather than follow the lawmakers' lead. Incoherence permits lawmakers to slide through with motherhood legislation—

laws that are as rich in aspiration and voter appeal as they are blank in content or efficacy. It also puts judges in a box. The standards lawmakers fix to guide the decisions of administrators serve as yard-sticks by which judges measure the validity of those decisions. But how is a judge to apply a yardstick whose calibrations blur into one another?

These problems do not arise when aesthetics judgments are made in the museum. The authority of these judgments resides in their persuasiveness, not in state coercion. Change the venue to the court-room or the legislative chamber, however, and such judgments become the law of the land.

Take the judgment that Building X merits preservation when made, respectively, by an architecture critic and by a lawmaker. The critic's

The "Law" in Legal Aesthetics

The pen of the cartoonist and the lens of the photographer often expose different facets of the same reality. Here, the cartoonist shows us what aesthetics law does by inverting the story line of the "Three Little Pigs"; the photographer captures the grim realities of how the law sometimes does it. Through the law's magic, the pig's house receives immunity from the wolf's (developer's?) threatened violence. And if the wolf doesn't listen? He may find himself at the other end of a policeman's gun, as did the bulldozer operator who fired up his machine to demolish the International Hotel at the edge of San Francisco's Chinatown.

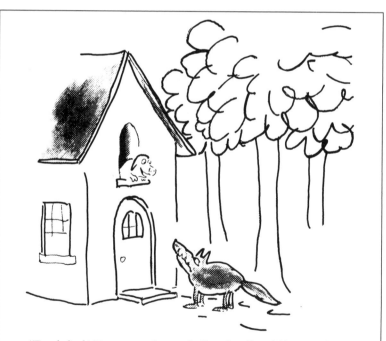

"Tough luck! You can no longer huff and puff and blow my house down. It's been designated a landmark."

judgment may bruise or enhance the architect's reputation, do the same to the critic's own reputation, or introduce the audience to a different way of experiencing architecture. None of these consequences is trivial, least of all the last. But the point here is that the critic's judgment will have no more effect than his or her audience chooses to give it. Some critics may aspire to more, perhaps to a pseudolegal esteem for their judgments because, as John Dewey observed, "the desire for authoritative standing leads [them] to speak as if [they] were the attorney for established principles having unquestionable sovereignty."[18] But we must not be misled. Absent the mandate of the state, these judgments can no more compel action or inaction than those advanced in any other nonlegal forum.

Suppose, however, that a lawmaker, New York City's Board of Estimate, for example, approves Building X's designation as a landmark on the basis of its officially declared aesthetics merits. Prior to the board's action its owners enjoyed a variety of freedoms. They could demolish it, redesign its facade, or spend a bundle or nothing at all to preserve the facade in its original state. But after the law has intervened, these freedoms will be restricted, often drastically, as Rabbi Feigelstock complained. The owners may be forced to feed a white elephant while they watch their neighbors replace non-landmarked buildings with lucrative office towers. The architect's plans for facade redesign must meet with the approval of the local landmarks commission; and autonomy over budgeting priorities may

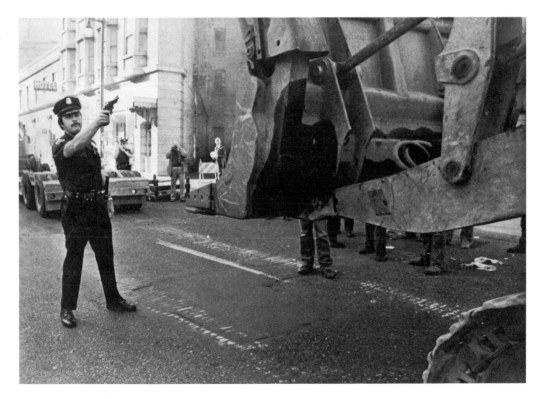

be forfeited—if a church or a charity, for example, the owners may be compelled to divert scarce funds from religious or social programs to a costly and, from their point of view, unwanted program of facade preservation.

These are only some of the consequences of moving from museum to courthouse aesthetics. I cite them now not to pass judgment on them but to emphasize that a powerful subsidy, coextensive with lost liberties, results every time the law is enlisted in aid of a social impulse. As a society committed to a broad range of personal and economic freedoms, we presume that we should not grant these legal subsidies in the absence of persuasive reasons for doing so. Confidence that we can define what we expect to achieve by legalizing the impulse is imperative. So too is assurance that the social gains and losses attending the subsidy will meet with broad citizen support. We seek to be persuaded as well that the law can handle the assignment faithful both to the impulse and to its own integrity. When in doubt on these matters, the proper course is to withhold the subsidy, leaving the groups who favor and oppose the impulse to slug it out among themselves.

In discussions leading to this volume, I found a strong disinclination to grapple with these tough questions among many supporters of the law/aesthetics union. As I view the matter, placing the legal system in service to social goals, aesthetics or otherwise, is a delicate operation that can easily go awry, however meritorious these goals may be by themselves. My discussants, by contrast, viewed law principally as a servant for or sometime obstacle to the achievement of their aesthetics preferences. Law ought to respond sympathetically to deeply felt social impulses, they insisted. Only a malcontent or, worse still, an academic purist would counsel caution in enlisting the legal system to eliminate the blight of billboards and slums, to preserve the nation's architectural and natural heritage, or to furnish plazas, gallerias, or even artwork for the subways of our cities. Besides, some argued, America has been pro-development for so long that it's about time the pro-aesthetics voice is heard. Our nation is in the midst of a struggle to determine whose values shall control the pace and character of environmental change. The post-1950s celebration of the law/aesthetics marriage signals that aesthetics values are finally winning out or, at least, holding their own.

Although not without merit, these claims must be evaluated within a larger context than the achievement of aesthetics goals alone. It is one thing for the legal system to view social impulses sympathetically but quite another for it to plunge ahead with an incomplete grasp of the whys and wherefores of the task set before it. The law is a fragile instrument. Used for the wrong job or misused for the right job, it harms itself and the community it ostensibly serves. Aesthetics regimes are prey to both ills, as chapter 2 records.

The second argument pleads, in effect, "No tough questions please

while things are going our way." In form, this argument tracks that made by any special-interest group: our values are best; the law exists to implement values; therefore, the law should implement our values. Two further elements are needed to convert this special pleading into principled reasoning, both of which, I argue here, can be found in a more searching appreciation of legal aesthetics' rationale. One is a coherent conception of what lies behind the impulse for importing aesthetics into the law. I have in mind something more, of course, than the question-begging demand for a "beautiful" environment. For all its emotional appeal, that formula tells us nothing about the kind of environment we want or what the law can or should do to bring it about. Worse still, it is dangerously overbroad, a defect to which I shall return. The second is a fair basis for resolving conflicts among contending groups. Not all groups agree that aesthetics values should prevail over other types of values, as the conflict between Rabbi Feigelstock and his West Side neighbors illustrates. Even those sharing a commitment to safeguard the environment's icons have been known to go after one another hammer and tong over whose aesthetics is best. How should such differences be resolved?

We wouldn't have to fret over this question if America were the Florence of the Medicis, the Rome of Julius II, or the Versailles of Louis XIV. Aesthetics policy in those societies derived not from democratic will but from the dictates of *signorie,* popes, or despots. Favored artists, such as Julius II's Alberti, or state-sponsored schools, such as Louis XIV's Académie Royale de Peinture et de Sculpture, formulated and superintended the design orthodoxy. Neither that orthodoxy nor a state-sanctioned linkage between government and artist, however, justifies the exercise of state power in the American constitutional system. On the contrary, justification must be predicated on broad popular will.

Aesthetics at Any Price or No Aesthetics at All

What we can expect from a legal aesthetics system lacking these two elements is clearly spelled out in Robert Nelson's *Zoning and Property Rights.* He posits that the "aesthetics" controversies with which the law deals feature neighborhood or community residents struggling to preserve their turf from outside threats, a blunt case of "us" and "them." The values being defended are dictated by neighborhood residents (in intracity squabbles) or by community residents (in intercity squabbles) and are not aligned with a broader public interest but reflect instead the neighborhood or community interests of the residents alone.

Nelson nonetheless urges that the law should do their bidding. "The immediate environment," he argues, "is a *private good,* subject

to standards of private consumption rather than to the requirements that normally must be met by public actions." Indeed, he goes further, advocating recognition of a "collective property right to the neighborhood environment that is effectively held and exercised by its residents." City councils, in Nelson's view, should serve "virtually as trustees for neighborhood residents,"[19] rather than as lawmakers compelled to respond to a more embracing public interest. The city, in short, is a club. Neighborhood groups constitute its members. And public officials, as the club's board, allocate the members' resources (their collective property rights) subject to the members' direction.

Nelson acknowledges the novelty of his claim that public land use controls should be turned over to private groups, but he insists that this is precisely the direction in which these controls are evolving anyway. His star witness: none other than legal aesthetics itself. Aesthetics measures, as he admiringly views them, function much as his collective property right to neighborhood environment because they transfer to private groups powers generally assumed to reside in government alone.

> The creation of public controls of a highly discretionary nature over neighborhood quality would virtually eliminate any substantive differences between such controls and those obtained under collective property rights. But numerous subterfuges would no doubt have to be employed and formal differences maintained, such as the assertion of "historic" value and other grounds for special treatment, to justify legally public controls. Rather than go through such contortions, it might be preferable to acknowledge the real purpose and openly to create private property rights where the majority of neighborhood residents want them.[20]

Nelson's realpolitik cannot be faulted in one respect: more often than we may wish to admit, appeals to aesthetics have been advanced to secure the privatization of public power. But his insistence that we worship at the altar of this practice is a bit much. Aesthetics is stripped of any independent meaning as an idea, functioning instead as an emotional lever facilitating the power grabs he advocates. Law reduces to little more than window dressing for this shell game. No opportunity is afforded for the political participation of groups whose views or interests differ from those of the neighborhood or community residents laying claim to their "collective property right."

And what about disputes among these residents themselves, Choi and his Park Avenue neighbors, for example, or Rabbi Feigelstock and his West Side opponents? If aesthetics—the supposed basis for resolving these disputes—is a sham, on what principled basis are they to be addressed?

If I shared Nelson's cynicism, my advice would be precisely the opposite of his: leave private matters to the private sector; dissolve

the law/aesthetics merger; and require those who formerly enjoyed the benefit of the law's subsidy to compete on an even playing field.

Others who agree with Nelson that legal aesthetics is a "subterfuge" writhing in "contortions" have urged this very course. They complain, as chapter 2 details, that the excesses propagated under the aesthetics banner are inevitable given the tension between the lucrativeness of its prizes and the lack of firm standards for distinguishing winners from losers. Granting a legal subsidy for aesthetics, they insist, only compounds the fraud. Better to steer clear of this impressionistic stuff and confine the law's attention to activities that directly imperil public health and safety in concrete, measurable ways.

The Dump Aesthetics movement is no fluke. Transforming the aesthetics impulse into coherent legal programs would remain daunting, even if the impulse's conceptual and administrative problems vanished. Aesthetics values, it must be conceded, are resistant to cost/benefit or similar quantitative tests. They spring from individual and group perceptions rather than from what we like to think of as "objective reality." Their quiddities cannot be defined nor their effects analyzed as accurately as the coliform count of drinking water. Soft, protean, and manipulable, these values do require thoughtful management by the legal system.

The Case for Legal Aesthetics

So why not discard legal aesthetics as a well-meaning but naive attempt to crank the legal system up for a task it can't handle? In part because we are condemned to come to terms with aesthetics, whether we like it or not. Aesthetics considerations are ubiquitous, "underl[ying] *all* zoning, usually in combination with other factors with which they are interwoven,"[21] as one judge has accurately observed. Lawmakers therefore must attend to these considerations unless they are prepared to shut down land use regulation in its entirety. To suppose, moreover, that the other values advanced by land use controls are hard, coherent, objective, nonmanipulable, and fully accessible to economics or any other form of analysis is to substitute one kind of tooth fairy logic for another.

What we mean by the term "environment" also bears reflection. Is the environment simply a spatial container within which our lives are organized along strict utilitarian lines, the vision implicit in the Dump Aesthetics critique and, it might be added, in conventional land use and planning theory? Urban ecologist Walter Firey has commented that those sharing this vision "have made of spatial adaptation a strictly economic phenomenon. They have begun by regarding all social systems as purely economic units. They have then postulated that the only socially relevant quality of space is its

"I'm sure it constitutes no clear and present danger, but it comes off as one helluva psychological threat."

Symbolic versus Physical Externalities

Claims of psychological harm have always troubled the law. Typical of its uneasiness is the comment of one judge, ruling on a National Environmental Policy Act case involving the location of a prison in an urban residential area: ". . . it is doubtful whether psychological or sociological effects upon neighbors constitute the type of factors that may be considered in making [a] determination [to prepare an environmental impact statement]" (*Hanly v. Kleindeinst*, 471 F.2d 823, 833 [2d Cir. 1972]). Yet it is precisely these effects that motivate communities to seek the enactment of legal aesthetics programs.

costfulness as an economic good. From these two premises, they have logically deduced that the city is a natural mechanism whose processes lead to a most efficient territorial layout of social activities."[22]

Those championing this cramped vision aren't likely to rate legal aesthetics' benefits highly, whether or not these benefits are discounted by their risks. It is no accident that the most strident assaults on legal aesthetics come from academic and government policy analysts imbued with the fire of classical economics.

I hold to a second vision, which adds to the first a perspective of the environment as a register of social values or, as Firey put it, a "symbol of the identity of a cultural system."[23] If economists can think of the environment as a Monopoly board on which economic games are played, why can't the rest of us think of it as a stage rich in icons invested with and broadcasting our deepest religious, artistic,

social, and personal commitments? I have no quarrel with theorists who advise that a leading purpose of land use law is "externalities control," that is, keeping the soot from your factory from dirtying the laundry hung in my backyard. But if land use theory is to reflect what people actually seek from public governance, it must go beyond soot and laundry.

"Symbolic externalities" distress people no less and, often, more, for we experience incompatibility as a clash among the messages we associate with the environment's icons and aliens. Driving every legal regime framed to nurture the aesthetics impulse, I am convinced, is the effort to prevent or minimize such associational dissonance. The Rice Mansion and deli battles dramatize how buildings or neighborhoods function as blotters sopping up varied associations. The mansion, for example, is the former palatial home of a plutocrat, the neighborhood's sole specimen of a gilded age and, in its Beaux Arts and Neo-Georgian design, a carrier of cultural genes dating

The Nation's Capitol: An American Icon

Icons come in all shapes and sizes and find support among diverse constituencies. Few are as monumental as the nation's Capitol, which, along with such companions as the Statue of Liberty and the White House, engages and confirms the values of Americans everywhere. Proposals to expand the Capitol's west front touched off widespread public opposition, championed in this instance by Senator Patrick Moynihan.

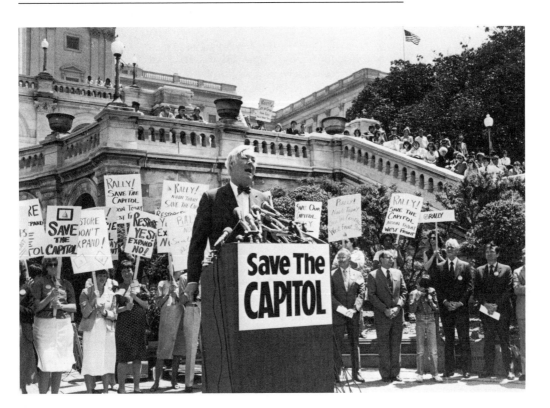

back to the Classical and Renaissance periods of Western history. The West Side, in Board No. 7's vision, is a "solid, low-rise, low-key, family-type" neighborhood, quite unlike the trendy, high-rise, fast-paced, swinging-singles East Side. And Park Avenue is, well, Park Avenue.

The mansion, the West Side, and Park Avenue are icons because their associations engage thought and feeling, both shaping and confirming the selfhood of those who fought against change. These associations serve as magnets, bonding constituency to icon. The same happens on a broader scale, of course: there is a sense in which the Eiffel Tower *is* Paris, the nation's Capitol *is* Washington, D.C., and the Statue of Liberty *is* America.

The environment is a visual commons reinforcing the ties we share as members of the various communities to which we belong. Painters, authors, and songwriters read the environment this way. Consider Utrillo's Paris, Dickens's London, or Cole Porter's Manhattan. So too does Lewis Mumford when he described the city not only as a "physical utility for collective living" but as a "symbol of those collective purposes and unanimities that arise under such favored circumstances."[24]

The environment shocks as well as nurtures, and never more so than when aliens threaten. To frightened West Siders the yeshiva's proposed tower was an "East Side building" trudging crosstown like

"The Sense of Self in a Place"

Snoopy's equilibrium is upset when a place to which he is deeply bonded is destroyed. As Donald Appleyard has observed, icons become "in some sense a part of ourselves," and the law's purpose in such conflicts is to preserve "the sense of self in a place." We human Snoopies generally regain our equilibrium in the face of such losses, but only when the progression of moods—shock to fantasy to depression—has run its course.

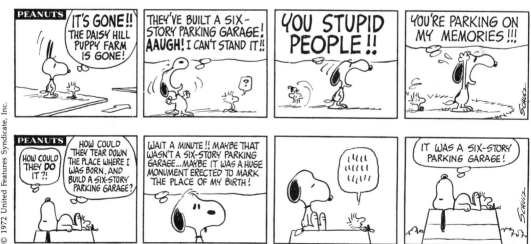

Icons and Aliens

an unshackled King Kong. Choi's zucchini signaled no less than the destruction of a way of life to his Park Avenue opponents.

If there is a case to be made for legal aesthetics, it must be centered in legal aesthetics' role as a regulator of change in the symbolic environment. Legal aesthetics does for the social system what homeostatic agents do for the human body. Physical health requires the maintenance of key biological constancies within the body. When they go out of balance, biological indicators signal the danger and homeostatic agents swing into action to re-establish equilibrium. Individuals and groups, too, must cope with the threats to their personal and social identity that icon-menacing aliens present. They expect that aesthetics measures will function in a socially homeostatic fashion by precluding, or at least minimizing, the shock of the alien.

The case is not a simple one to make, however. The museum/courthouse confusion must be eliminated. At present, neither American society nor its legal system fully grasps what each expects of the other in this delicate enterprise. Even if they did, effective teamwork would not be guaranteed. Those frightened by the uncertainties of change will remain disposed to invoke aesthetics to engineer the privatization of public power advocated by Nelson. Park Avenue residents, for example, might continue to insist upon Belgian chocolates rather than zucchini in "their" neighborhood. And if such demands are made, how will the legal system react? Are legal doctrine and legal institutions equipped to evaluate and adjudicate such claims? A reasonable accommodation between aesthetics and law can be fashioned, I believe, but only if we examine closely the course of the marriage to date.

Aesthetics and the Legal System

American judges, administrators, and lawmakers have been caught off guard by aesthetics from the very beginning. Their befuddlement has led, in turn, to successively unbalanced assessments of the law's ability to manage aesthetics controversies. Judges scorned aesthetics back around the turn of the century because they believed, correctly, that the state had no business regulating beauty, nor could it do so if it tried. Regrettably, they failed to distinguish legal from museum aesthetics and, therefore, to consider whether a stability-based aesthetics is within the state's purview.

Today's judges have come full circle, but not because they have labored over this distinction. On the contrary, most have embraced beauty as legal aesthetics' justification in opinions that seldom acknowledge, let alone dispel, the concerns advanced by their more cynical predecessors. Lawmakers, administrators, and citizens groups have been quick to seize upon the modern judiciary's indiscriminate stance. Countless aesthetics initiatives have streamed through the floodgates the judges have unlocked. Many of these initiatives are superb, both in concept and administration. Others have been neither, rendering legal aesthetics vulnerable to the Dump Aesthetics critique.

This chapter pulls these trends together by describing the quandaries of doctrine and institutional role now confronting lawmakers, administrators, and judges. Law-bashing is not my purpose. If anything, I write with sympathy for the legal participants in America's aesthetics drama. They are only trying to do a job demanded of them by the rest of us, and their uneven performance speaks far more to our faulty expectations than to their inadequacies. Nor does what follows constitute a mini-treatise on the law of aesthetics. My focus is legal aesthetics' foundation, not its superstructure, and my selection of doctrinal and institutional issues has been fashioned accordingly.[1]

The Swinging Pendulum

The Hostility of the Past

A set of linked questions arises whenever we insist that a social impulse be legalized. What public purpose, if any, will be served? Can lawmakers, administrators, and judges handle the job consistent with the constitutional constraints that cabin their roles? Will liberty or property rights reserved to citizens be infringed?

When faced with demands for the legalization of the aesthetics impulse, judges of an earlier period balked because they could find no satisfactory answers for these questions. Distress over public purpose and private property rights appears, for example, in the following opinion, representative of its times, invalidating a billboard control ordinance: "No case has been cited . . . which holds that a man may be deprived of his property because his tastes are not those of his neighbors. Aesthetic considerations are a matter of luxury and indulgence rather than of necessity, and it is necessity alone which justifies the exercise of [governmental] power to take private property without compensation."[2]

An implicit concern for the citizen's entitlement to freedom of expression and personality is added to the public purpose issue in another early billboard case.

> The cut of the dress, the color of the garment worn, the style of the hat, the architecture of the building or its color, may be distasteful to the refined senses of some, yet government can neither control nor regulate in such affairs. The doctrines of the commune invest such authority in the state, but ours is a constitutional government based upon the individuality and intelligence of the citizen, and does not seek, nor has it the power, to control him, except in those matters where the rights of others are injuriously affected or imperiled.[3]

Questioned in a third opinion, which vetoed an ordinance excluding apartment houses from a neighborhood, is the ability of legal institutions to fulfill their constitutional roles in conceiving and administering aesthetics programs. Fretted the opinion writer: "Certain legislatures might consider that it was more important to cultivate a taste for jazz than for Beethoven, for posters than for Rembrandt, and for limericks than for Keats. The world would be at continual seesaw if aesthetic considerations were permitted to govern the use of [governmental] power."[4]

Modern commentary dismisses these opinions as relics from the past. Billboard control and apartment house zoning are commonplace today, it is noted, and the judiciary's readiness to champion laissez-faire ended in the Roosevelt era. Both points are true, but neither addresses the serious issues of constitutional and social principle posed in these opinions. While we may flinch at the claim that aesthetics is merely a "matter of luxury and indulgence," what state

interest is advanced by the pursuit of beauty? If beauty is what the law seeks, how are lawmakers, administrators, and judges to proceed given the reality that some of us do indeed prefer jazz over Beethoven, posters over Rembrandt, and limericks over Keats? As citizens, are we comfortable with state dictation of "the cut of the dress, the color of the garment worn, [or] the architecture of the building or its color"? And as property owners, how do we feel about restrictions as severe as those imposed in the Rice Mansion controversy, particularly if satisfactory answers to the three previous questions are lacking?

"With this sculpture, the current crisis between the object and the image reaches into the more fundamental conflict between the metaphysical angst of the first-generation Abstract Expressionists and the space-environment preoccupations of the avant-garde."

Museum Aesthetics

For the better part of the twentieth century, judges have feared that the law's foray into aesthetics would obligate them to evaluate the types of claims advanced by this cartoon's speaker or to choose between jazz and Beethoven, posters and Rembrandt, or limericks and Keats. Their fear would be justified if museum and legal aesthetics were identical. Fortunately, the two are not. Despite its many complexities, the aesthetics of the courtroom is neither as abstruse nor as resistant to analysis as the aesthetics of the museum.

Icons and Aliens

The Enthusiasm of the Present

Early judicial hostility led most courts through the mid-1950s to rule that the government may not zone "solely for aesthetics," a formula that crimped aesthetics zoning but did not close it down. Judges struggled to find nonaesthetics purposes in aesthetics measures and to sustain them despite their obvious aesthetics content. Anticipating the flights of fancy that would ensue is a 1911 opinion upholding billboard control because, its imaginative author insisted, billboards are "constant menaces to the public safety and welfare of the city; they endanger the public health, promote immorality, constitute hiding places and retreats for criminals and classes of miscreants. . . . the evidence shows . . . that the ground in the rear thereof is being constantly used as privies and dumping grounds for all kinds of waste and deleterious matters, and . . . behind these obstructions the lowest form of prostitution and other acts of immorality are frequently carried on, almost under the public gaze."[5]

This silliness had to end. Americans wanted and were entitled to aesthetics regulation even if they seemed unable to state and, perhaps, to understand why. The legal system wished to accommodate them and found itself increasingly embarrassed by the fictions it was concocting. The end came with the United States Supreme Court's 1954 opinion, *Berman v. Parker*, sustaining the District of Columbia's urban renewal program against the charge, among others, that the program was aesthetically based. The Court agreed that it was but turned the tables on the program's opponents by concluding that aesthetics strengthened rather than undermined the district's legal position. In a passage that broke the aesthetics logjam, the Court declared: "The concept of the public welfare is broad and inclusive. . . . The values it represents are spiritual as well as physical, aesthetic as well as monetary. It is within the power of the legislature to determine that the community should be beautiful as well as healthy, spacious as well as clean, well-balanced as well as carefully patrolled."[6]

Word quickly hit the street that the government may legislate "solely" for aesthetics, which, the Court confirmed, envisages "beautiful" communities. What followed was an outpouring of legislation expanding aesthetics programs in existing fields such as historic preservation and initiating them in others such as urban design. And the judges? Norman Williams, one of the deans of American land use law, confirms their conversion in his comment that "in no other area of planning law has the change in judicial attitudes been so complete."[7]

The National Highway Beautification Act,[8] which seeks to stem proliferation of billboards along federally assisted highways, is one of *Berman*'s progeny. The expansion of the urban renewal program in the late-1950s and in the 1960s was facilitated by *Berman* as well.

More recently, lawmakers have launched a variety of innovative land use controls to enhance the aesthetics of America's cities. Among the best known is incentive zoning, now in place throughout the nation, which permits developers to construct larger buildings in return for plazas, galleries, and other design amenities that cities are often unable to fund themselves.

Historic preservation also leaped forward during this period. By the time the nation's bicentennial rolled around in 1976, preservation's ranks had ballooned. The movement shed its antiquarian image by building bridges to powerful allies in political, financial, and ethnic circles. And by 1988 more than 1,000 cities had adopted landmark and historic district regulations. No dead letters, these laws have created preservation agencies with powers and turf that in some cities are beginning to rival those of longer established zoning and planning agencies. Illustrative is New York City's landmarks commission, which in 1985 controlled 2 percent of that city's 850,000 properties. Among its charges were 696 individual landmarked buildings and 48 historic districts encompassing 16,000 buildings, not to mention 2 trees, 7 sidewalk clocks, 5 bridges (the Brooklyn Bridge among them), 9 parks, parkways, and drives, and 45 building interiors. The commission passes on most changes affecting these features, a task that required it to review 1,802 requests in one twelve-month period alone. Moreover, during 1975-85 the commission undertook to survey the architectural significance of *every* building in the city.

Congress has gotten into the act as well, as two of its better known pieces of preservation legislation attest. In 1966 it added Section 106 to the National Historic Preservation Act,[9] which authorizes the President's Advisory Council on Historic Preservation to review federal projects threatening properties listed or eligible for listing on the National Register for Historic Places. By 1985, over 20,000 projects had been reviewed in a consultative process in which the council seeks to negotiate modifications that protect a property's distinctive characteristics while permitting the federal project to go ahead. In 1978 Congress amended the Internal Revenue Code[10] to extend federal income tax benefits to property owners who rehabilitate their buildings in conformance with government-certified plans. From 1982 to 1985 this amendment stimulated an estimated $8.8 billion of investment in more than 11,700 historic buildings.

Another post-*Berman* development is the neighborhood conservation movement, whose adherents often occupy working-class, architecturally undistinguished neighborhoods such as New York City's Hell's Kitchen. Initially, neighborhood conservationists clamored for "citizen participation" in the hope of achieving parity with the government and the developers in reviewing programs that threatened to alter the physical and social fabric of their neighbor-

hoods. Later, many sought the protection of historic preservation laws, which afford immeasurably greater protection against neighborhood change than do zoning laws.

Unwanted development can be stymied by pre-emptive designation, the strategy pursued by the West Side's Board No. 7. Preservation laws also empower landmarks commissions, which properly advocate conservation values, to superintend virtually any type of work, be it a new coat of paint, cornice repair, or, as in the deli battle, the replacement of a wood door with a glass one. Zoning codes, by comparison, accord their administrators less discretion, ignore the design features of individual buildings, and, traditionally at least, seek to encourage new construction rather than conservation of the old.

Although last on my list, Congress's 1969 approval of the National Environmental Policy Act (NEPA)[11] is arguably the most significant of the pro-aesthetics initiatives chronicled here because it forced a petulant federal government to take environmental values seriously. Prior to NEPA, federal agencies could ignore these values when they constructed dams, financed interstate highways, or licensed nuclear plants. Under NEPA, however, they must detail a project's effects on these values in "environmental impact statements" prepared at the project's outset and publicized for critique by other public bodies and by environmental watchdog groups, such as the Sierra Club or the Isaac Walton League. NEPA does not ban environmentally harmful projects outright, but it does obligate sponsoring agencies to identify these harms and, to the extent compatible with its competing responsibilities, to mitigate or avoid them. Federal courts are authorized to enjoin projects when these obligations are ignored.

Unnoticed by many commentators is that an honored place for aesthetics values is reserved by NEPA and the so-called Little NEPAs, state-level environmental acts that track their federal parent. Among NEPA's stated purposes are ensuring "aesthetically and culturally pleasing surroundings" and preserving "important historic, cultural, and natural aspects of our national heritage." In addition, NEPA obligates all federal agencies to cultivate "the environmental design arts" and to highlight "presently unquantified environmental amenities and values"[12] in drawing up the balance sheet of a project's costs and benefits.

Environmental legislation redefines not only how decisions about environmental change will be made but who will make them and according to what timetable. For the first time in the nation's history, federal and state agencies must submit their projects to searching public, administrative, and even judicial scrutiny. Development at the state and federal levels, like that at the municipal level, is no longer a two-hatted affair between government and contractor. Environmentalists, represented by such groups as the Environmental

Defense Fund and the Natural Resources Defense Council, have seized upon the opening presented them to expand their influence in Washington and at the state capitols. Skilled in the arts of public relations and lobbying, these groups now participate as, in effect, a fourth branch of government in the formulation of legislative and administrative proposals as well as in actual project design.

When frustrated on these fronts, environmental groups may resort to litigation thanks to NEPA's citizen lawsuit provisions. The leverage this option brings them is difficult to overstate. It is not so much that they may win in court, although they often do. Rather, litigation's years-long delays alone may defeat contested projects or force their redesign by exposing them to unfavorable publicity or increasing their costs far beyond initial estimates. Witness the demise after a decade-long battle of Manhattan's Westway project in the face of its advocacy by four United States presidents, most of New York State's congressional delegation, two governors, two mayors, and a large slice of Manhattan's power elite.

The judiciary's turnabout, as noted, followed close upon the heels of the United States Supreme Court's encomium to aesthetics in *Berman*. Witnessing it is the avalanche of opinions from other federal and state courts putting steel into NEPA and Little NEPAs, confirming the government's power to zone "solely for aesthetics" and, in general, elevating aesthetics values to first rank. Aesthetics, land use, and environmental concerns, most American judges now believe, merit their firm support as contributing partners to what the Supreme Court has termed the "quality of life."[13]

A Blessed Union?

Is the union of law and aesthetics the love match these trends suggest, proving groundless the doubts of earlier judges? Yes and no. Seen from one angle, the partners have chosen well, and we are all in debt for their ardor. The legal system has become attuned to linkages between us and our environment that were previously ignored. Broader still, basic premises shaping the goals, techniques, and reach of the law have been transformed. The bad news is that a coherent conception of aesthetics remains as elusive for modern judges as it was for their turn-of-the-century counterparts. In consequence, unintended and occasionally distressing consequences have eroded the expectations generated by post-*Berman* aesthetics initiatives.

One rose whose bloom has paled is the National Highway Beautification Act. Now described as the "environmental movement's greatest failure,"[14] the act has actually made it harder to rid the highways of billboards, not easier. It has become the captive of the billboard industry, which has riddled it with loopholes, including

The sign in the illustration reads:

LANDMARKS OF NEW YORK
THIS ROW OF BROWNSTONES
HAS NO PARTICULAR HISTORICAL
OR ARCHITECTURAL SIGNIFICANCE.
JUST ROUTINE POST-CIVIL WAR
HOUSING, AND RATHER
UNIMAGINATIVELY CONCEIVED
AT THAT.

Historic: What's In and What's Out?

The humor of this cartoon, drawn in an earlier decade, is less apparent at the present time when, as Richard Babcock and Clifford Weaver comment, "historic has come to mean practically anything that . . . is not run-of-the-mill." The term "conservation" more accurately describes much that goes under the name of "historic preservation." The aesthetics impulse has gotten ahead of its labels and mistaken rationale, creating needless confusion. The solution: call the thing what it is and manage it through more finely tuned conservation zoning, not through spurious claims of historic value.

THE FUTURE OF TRINITY CHURCH.

Frankenstein Zoning

The development scenario parodied by *Puck* in 1907 became a reality in New York City eight decades later. Submerging the landmarked Villard Houses (bottom center of photograph) in a sea of the Helmsley Palace's swarming density wasn't an oversight because this danger was explicitly cautioned against by writers, like the author, who engaged in early analyses of the transfer of development rights (TDR) technique employed in the Villard Houses–Helmsley Palace development. These risks advise that ideas initiated with the best of aesthetics intentions and labeled with pointed warnings may produce results at odds with these intentions, particularly in overheated urban real estate markets.

Icons and Aliens

one that forces state governments to foot the bill for billboard removal in cases in which these costs would have fallen on the industry prior to the act's passage.

Urban renewal, too, is less kindly regarded today than when the Supreme Court embraced it back in 1954. Its stated goals of battling slums and blight, numerous follow-up studies confirm, often serve as a cover under which powerful downtown interests, aided by political machines and federal funding, seize control of strategically located areas from their former residents—usually the poor and minority groups. Urban renewal also demonstrates how programs that are sold on aesthetics grounds frequently conflict with other programs that are similarly touted. It has, for example, leveled countless neighborhoods, such as Boston's West End, that historic preservationists insist never should have been lost.

Incentive zoning has run into its share of problems as well. Ada Louise Huxtable, former architecture critic of the *New York Times*, has termed it "Frankenstein zoning" in her host city, where it has been pressed into service to justify buildings that dwarf even the light- and air-blocking slabs that frightened the city into adopting the nation's first zoning code in 1916.[15] It has also transformed reasonably impartial zoning procedures into a crapshoot. Eager to finger the dice are the handful of developers and lawyers who actually understand what is written—and not written—into the code; city planners thirsting to design the developer's building or to select favored architects for the job; developers willing to go along in return for outsized gobs of extra building space; and mayors panicked by developers' threats to take their buildings elsewhere if that space is not forthcoming.

Results on the preservation, conservation, and environmental fronts are also mixed. Historic districting laws have received the backhanded compliment of Clifford Weaver and Richard Babcock, respected land use commentators, as a "splendid, if somewhat contrived device," because "historic has come to mean practically anything that, in some fashion or other, is not run-of-the-mill."[16] Blunter still is Beverly Moss Spatt, former chair of the New York City Landmarks Preservation Commission. She has complained about the "growing tendency to use designation for purposes outside the law and even at times explicitly denied to the . . . Commission by law," adding that "people are requesting and gaining designation for a whole array of . . . [improper] reasons: to maintain the status quo, to prevent development, to revitalize an area, to gentrify, or gain tax benefits."[17]

Weaver and Babcock record similar trends in their portrayal of the neighborhood conservation movement's utilization of land use measures, many of which include a strong aesthetics component. Hence, their comparison of recently arrived residents of gentrified or gentrifying neighborhoods to "folks who are still fighting to keep the walls up around their suburb or the Vermont environmentalists who

Icons and Aliens

TO BE BUILT ON THIS SITE

A NEW
BROWNSTONE
SPACIOUS ROOMS
HIGH CEILINGS
SOUNDPROOF WALLS
GRACIOUS FIREPLACES
AIRY KITCHENS

Goals and Effects

Swings in fashion occur in architecture no less than in clothing design or cuisine. The trend toward the split-level and modern is reversing itself, and builders have responded with "new" brownstones and explicit appeals to live in a landmark. Historic now sells. The newfound harmony between preservation and the marketplace is not without its dangers, however. Norman Williams noted that "to the extent that a designation for historic preservation becomes a symbol of prestige, it is likely to be sought by and on behalf of all sorts of neighborhoods/communities with no historical value whatsoever—in which case it becomes not much more than a vehicle for local real estate promotion" (Williams, *American Land Planning Law*, vol. 3, sec. 71A.05).

Move into a Greenwich Village landmark. Tomorrow.

Imagine looking out of gracefully arched windows and into the peaceful courtyard of one of the world's Gothic masterpieces. The Grace Church, built in 1846 by James Renwick, Jr., the very same architect of St. Patrick's and The Smithsonian, still stands today at Broadway and Tenth Street, adjacent to the Renwick design that bears his name: The Renwick, an historic cooperative.

That The Renwick is an historical treasure is one thing. That one can live in it today is quite another. (In fact, you may take that quite literally—people are already moving in.)

From its original, carefully restored ironwork gate to its skylit, 24 hr. attended lobby and private interior courtyard and garden to its elegantly designed cooperative spaces, The Renwick has been treated like the landmark it is.

Whatever original detailing could be saved has been preserved—and is only enhanced by the quality of modern technology and planning.

That the ceilings are high is expected. But 25-foot living rooms are considered rare, except in lofts.

Here, the spaces are large, airy. Kitchens are open, inviting. Windows are thoughtfully placed, complementing the rooms they look out from. Closets are plentiful, baths roomy, floors, oak. Cabinets are abundant, appliances to match.

There are balconies overlooking our landscaped gardens, there are lofts for storage or sleeping. There are duplexes, garden apartments, and no less than eleven penthouses, complete with rooftop terraces and mind-boggling views. A total of 68 well-planned living environments, from studios to three bedrooms, 575 square feet to 2600 square feet in size.

Admit it. Part of you always wanted to live in the Village. Now imagine celebrating your housewarming in less than a month.

Come, visit The Renwick, an historic cooperative. And own a piece of history.

The Renwick

An historic cooperative.
808 Broadway at Eleventh Street
(212) 674-2111

MANY CHOICE APARTMENTS REMAIN - IMMEDIATE OCCUPANCY.

Icons and Aliens

moved from New York last year . . . [who] have implicit faith in their own good motives but are convinced that the public health, safety, and welfare demand a zoning ordinance to control the libidinal tendencies of others to pillage, plunder and rape 'their' turf."[18]

Questionable uses of environmental quality legislation in areas outside the nation's cities have also been an unwelcome accompaniment of the broad discretion this legislation confers on local governments. In *The Environmental Protection Hustle*, Bernard Frieden summarizes a variety of these practices in Marin County, California, which he describes as "the best place to look for an understanding of what it means to stop suburban growth in the name of environmental protection. It means closing the gates to people who may want to move in and, where possible, even to people who may want to visit; turning to state and federal governments for help in paying the costs of exclusivity; and maintaining a tone of moral righteousness while providing a better living environment for established residents."[19]

Parallel assessments are commonplace in studies following Frieden's book, one of the first of an emerging genre of anti-environmentalist muckraking literature. They also figured prominently in the New Jersey Supreme Court's imposition of a judicial receivership on the state's municipalities in 1983 in a desperate bid to stop them from using their land use and environmental powers to exclude the poor from their borders.[20] Such distressing trends warn against too lenient an attitude toward the incoherence that pervades legal aesthetics. No legal field enjoys perfect lucidity, to be sure, and even coherent laws may be twisted to dubious ends. But it hardly follows that minimal coherence is beyond reach in legal aesthetics or that the law's failure to achieve it is unrelated to the foregoing problems.

A Return to First Principles

So where do we go from here? I would suggest that we work backward from the dilemma with which we began: the law knows nothing about aesthetics, yet we speak of a law "of" aesthetics. How can there be a law "of" something that is not itself law? How do concerns initially outside the law pass through its portals? What duties devolve upon lawmakers, administrators, and judges as keepers of the gate?

Legal Aesthetics' Process and End-State Values

We might begin by recognizing that the law "of" aesthetics, like the law "of" anything else, is in fact two distinctive types of law, or, better yet, the crossing point between two distinctive sets of values. One set clusters around the achievement of specific aesthetics

The Environment as a Symbol System

The environment's many features constitute a system of symbols no less articulate than the words of this book. How a culture builds tells volumes about its beliefs and values. Western medieval culture reserved its most valued sites and dominant vistas for its churches, such as the Chartres Cathedral; ours reserves them for its business palaces (opposite page: the Fourth Presbyterian Church in Chicago, adjacent to Bloomingdale's and its skyscraper).

outcomes — barring billboards from scenic highways, let us say. This set of values might be referred to as legal aesthetics' "end-state" values. They are the "law" that citizens have in mind when they urge, "There oughta be a law!" And for those who think of law principally as aesthetics' servant, they tell the greater part of the story.

There is a second set of values that have nothing to do with aesthetics outcomes, as such, termed here legal aesthetics' "process" values. These ensure that aesthetics outcomes and the manner by which they are reached respect values that should discipline *any* public program, aesthetically oriented or otherwise. Chief among these values, as we have already seen, are public purpose, liberty and property rights of citizens, and division of functions among lawmakers, administrators, and judges.

Alliances between end-state and process values, like those between nations, are never tranquil: a common goal brings them together but never so well that it snuffs out underlying tensions that complicate the relationship. Let us examine these values, therefore, and,

Icons and Aliens

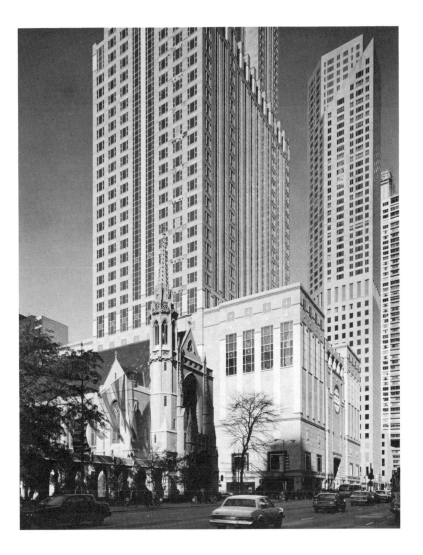

with greater appreciation of their potential for strife, reflect upon the challenges the gatekeepers face in keeping the alliance intact.

End-state values are prelegal. They emerge, struggle for recognition, and eventually take hold within the larger society, which only then clamors for their incorporation into its legal system. Aesthetics law thus receives its end-state values from beyond; it does not spin them out, spiderlike, from its belly. A proposal in medieval times to allow a commercial building to rise higher than the local cathedral, for example, would have shocked the populace by its symbolic inversion of religious and secular values. Not so in twentieth-century American cities, where churches are commonly dwarfed by nearby palaces of commerce. Desecration, too, would have been the charge levied by nineteenth-century native Hawaiians against the construction of high-rise buildings around the Punchbowl, then a sacred burial ground. But the capitalist descendants of the mainland missionaries who undertook to "civilize" the Hawaiians don't see

things the same way. The sacrilege in their view would be a failure to put the Punchbowl's environs to what their tribe chooses to call its "highest and best use."

Prelegal, not legal, values determine the outcome of such conflicts. But which set of prelegal values should the law prefer? That is a question the law cannot answer from within. Rather, it must look beyond to the values of the society it serves. Awaiting the maturation and presentation of end-state values are lawmakers, who are the bridge between society and its legal system, and administrators, who implement the values that lawmakers endorse. End-state values take form either as aesthetics legislation or as decisions applying this legislation to specific situations. NEPA, the Federal Highway Beautification Act, and San Francisco's urban design regime illustrate the former; designation of Seattle's Pioneer Square as a historic district or of Louis Sullivan's Auditorium in Chicago as a landmark, the latter.

Process values, by contrast, originate in the Constitution and the Bill of Rights. While these texts, too, ultimately express societal preferences, process values have the feel of what we intuitively think of as law with a capital L. They are also more durable than end-state values. Rarely amended, the Constitution and the Bill of Rights have been around since the nation's birth. Aesthetics statutes, which emerged relatively recently in the twentieth century, have a limited shelf life. The incentive zoning schemes introduced in New York and San Francisco in the 1960s, for example, have been repeatedly overhauled since then.

Black-robed judges are process values' ultimate guardians. Unlike lawmakers or administrators, judges play no role in the formulation of aesthetics measures and are insulated from the day-to-day political pressures that buffet their more exposed legal colleagues. They are indifferent to the merits of end-state values, as such, scrutinizing them only to ensure that process values have not been compromised in their adoption.

Judges speak through legal opinions, not through statutes or regulations. Therefore, process law must be squared not only with constitutional texts but with the fabric of precedent. End-state law escapes these burdens of exposition, consistency, or rationality. It need only survive the vicissitudes of the political arena. Process values define the ground rules for battles between contending interest groups. Like the Marquis of Queensbury's rules for boxing, they seek to assure a fair fight, not to determine who will win.

Legal aesthetics, in short, is a product of the tension between two sets of values with different sources, goals, and legal champions. A blissful marriage of law and aesthetics assumes that end-state values, newly received into the law by legislators and administrators, will respect constitutionally based process values, whose ultimate guardians, of course, are the judges.

Process and End-State Values at Loggerheads

The course of true love never runs smooth, especially for the partners in question. Why so? For openers, aesthetics regimes inevitably subsidize some interests at the expense of others. Designating an area as a historic district, for example, may increase the residents' property values or provide tax benefits to developers. But it may also deprive the area of its family character, drive out minority or lower-income residents, or force architects to conform their designs to some official style. Needless to say, those perceiving themselves as potential winners and losers hammer away at the legal system to make sure that they come out on top.

Consider the choice you would face if you were a New York City lawmaker presented with a petition to designate the city's Lower East Side as a historic district. Scruffy and crime-ridden, this neighborhood began to experience an influx of Yuppies and boutiques, along with other signs of gentrification, in the late 1970s. Predictably, reactions to impending change split its residents into warring camps. To Susan Kelley, a junior Wall Street broker and recent resident, the presence of "so many young professionals sitting on the stoops, ties undone, just talking," is delightful because "there's a feeling of togetherness, of movement."[21] Barbara Schaum, a leather-crafter who has lived in a Lower East Side loft for more than twenty years, has a different vision: "I see them walking down the street in identical blue suits with their briefcases and I think, 'There goes the neighborhood.' Why are all these people coming here, where they're so riotously out of place? I don't want my neighborhood to change."[22]

Similar divisions have arisen over the area's name. Real estate people call it the East Village to stress its proximity to the chic Greenwich Village neighborhood (and historic district) to the west. But old-timers object. "As soon as they said 'East Village,'" one grumbled, "they tripled the rent. It's the East Village to real estate brokers. To us, it's the Lower East Side."[23] Eventually, some group will no doubt petition to retitle the Lower East Side the East Greenwich Village Historic District. No less predictably, that proposal, if approved, will accelerate the trends welcomed by Susan Kelley and deplored by Barbara Schaum.

How would you vote?

Conflicts between process and end-state values also flare up because legal aesthetics is theater no less than law. Aesthetics regimes respond to our perception of the environment as a stage, rich in icons that infuse our lives with constancy, self-confirmation, eroticism, nostalgia, and fantasy. Identity and a sense of continuity are the quarry of these regimes, which promise to secure what Barbara Schaum and all the rest of us seek when the most reassuring features on that stage are suddenly imperiled—release from the anxiety of uncontrolled or unwanted change.

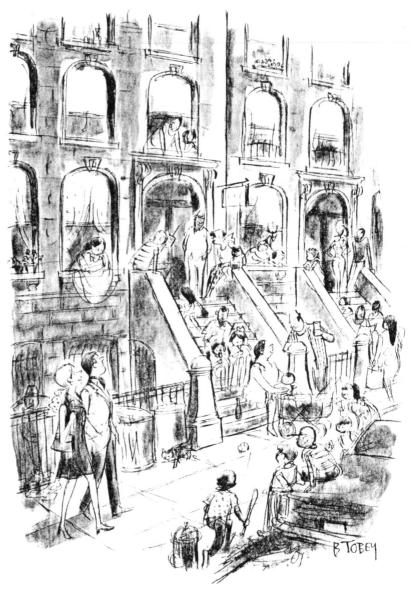

"Oh, Pete, what fun we could have doing over one of those brownstones!"

The Icon as a Trojan Horse

Paradox: preserving an area's physical character may destroy its social character. If Pete and his Yuppie friends do over enough of the brownstones depicted in this cartoon, the neighborhood's present residents will soon be displaced. It happened in San Francisco's Castro District, in New York City's Brooklyn Heights, and in neighborhoods elsewhere. Whether neighborhood transformation is good or bad depends upon whether you are Pete or one of the children playing stickball on the sidewalk. What is clear is that the social effects of a proposed aesthetics regime should be as carefully examined as its visual effects.

When icons are assaulted, *we* are assaulted. The language we use to condemn these assaults is metaphor crying out against sexual or military outrage ("rape," "plunder," "invasion"), mutilation ("scar"), blasphemy ("sacrilege"), and disintegration and death ("obliterate"). This is frantic, gut stuff, not the studied discourse of the Academy. The emotions it unleashes move people to chain themselves to bulldozers, descend on lawmakers in frenzied lobbying campaigns, and underwrite costly, last-ditch lawsuits. The aesthetics in question is not some erudite, museum-bound creature. It is the immediate, gripping reality aptly termed "the sense of self in a place" by Donald Appleyard.[24]

No one should be surprised, therefore, that end-state values dwarf process values for those cringing at the prospective loss of cherished icons. Nor can we ignore legal aesthetics' incoherence, which bores at process values from within the legal system itself. Bewildered by the museum/courthouse confusion, many lawmakers and judges fail to distinguish genuine from specious threats to process values or even to understand which process values are at stake.

The Aesthetics Impulse

The social force driving legal aesthetics is the emotional distress we experience when our individual and collective identities are assaulted by attacks on our cherished icons. Icons become so because their embedded associations run the gamut of values expressive of those identities. What these values will be in a particular case depends upon the icon in question. Our emotional response to these threats is commensurate with our commitment to the values. Hence the outraged metaphor used to excoriate these threats and the embattled visual images employed in these cartoons.

"Damn the torpedoes. . ."

Legal Aesthetics and Legal Institutions

Shelter from the emotional blows suffered when cherished environmental features are pillaged—this is the prize legal aesthetics offers; this is why it commands impassioned support despite the excesses of its first generation; and this is why that support must be discerning, not indiscriminate. If aesthetics is Dionysus, then law must be Apollo.

Lawmakers

Whether or not law can nurture the aesthetic impulse without overlooking process values is legal aesthetics' unique challenge. Consider this from the angle of the lawmakers, the first of the legal actors to encounter community demands for aesthetics measures. At the threshold, they need some basis for determining which end-state values to endorse and which to spurn. But if these values are prelegal in origin, on what basis should they evaluate them? On what basis would you do so?

How, for example, should Buffalo's legislators deal with that city's grain elevators? The world's busiest grain shipper back in the 1920s, Buffalo featured many such structures, described by French architect Le Corbusier as "the magnificent fruits of the new age."[25] But Buffalo's active grain-shipping days are over. What to do with them? The Preservation Coalition of Erie County, a private citizens' group, insists that they be preserved as "architectural ruins" or adapted to some new use. Buffalo's director of economic development disagrees. "It's important to hold on to symbols of the past," he concedes, but "how many symbols do you need?" He advises, in a phrase already heard, that "the waterfront has to be put to the best, highest use," and he warns that the elevators are a "safety hazard."[26] How should Buffalo's lawmakers vote: to preserve them as an inspiration from the past, or to demolish them as a blight on the waterfront? The locale and the resource may differ, but the same question arises countless times before countless lawmaking bodies throughout America.

Lawmakers must also anticipate whether the demands that come before them square with process values. A delicate task, it obligates them to identify the particular process values at risk, and to decide—in advance of any judicial declaration on the question—how the demands stack up against these values. Take the instance of government-mandated design controls, the backbone of any legal aesthetics regime and, in the illustration at hand, of historic district regulation. A townhouse located in the Greenwich Village Historic District was blown up back in the Vietnam protest era when explosives that were being assembled there by a group of Weathermen accidentally detonated. Hugh Hardy, one of the nation's most in-

ventive preservation architects, acquired the site and proposed a replacement that conformed with neighboring buildings in all respects but one: its protruding, second-story bay, which Hardy included as a gesture to the site's tragic history.

Suppose the city's landmarks commission (an administrative agency but nonetheless apt for this context) were faced with community demands that it censor Hardy's design on grounds of "aesthetic incompatibility" with Greenwich Village's existing architecture. How should it respond? Sensitivity to First Amendment process values would require it to identify and tentatively resolve two questions: Would endorsement of these demands deny Hardy his freedom of expression, as surely would be true if the government were to order Martha Graham to choreograph levity into *Agamemnon* or Igor Stravinsky to soften the dissonance in *The Rite of Spring?* Or is there

Joe Travers/NYT Pictures

Selecting Icons

Deciding whether an environmental feature merits legal protection as an icon is often problematic. Should lawmakers concur, for example, in the insistence of Albert Guerard that the entire city of Paris be listed as a monument or of Wolf Von Eckardt that similar status be conferred on America's great historic skylines? Or take Buffalo's grain elevators. Is it sufficient that Le Corbusier viewed them as the "magnificent fruits of the new age" or that the Preservation Coalition of Erie County canonizes them as "architectural ruins"? How are such claims verified? And how can lawmakers confirm that these claims accord with community sentiment? Tough questions all, but each must be answered if legal aesthetics is to be a coherent enterprise.

Compatible or Incompatible

Eleventh Street, including the townhouse destroyed in the Weathermen explosion, is featured in the top photograph. Hugh Hardy's design for the Greenwich Village townhouse, as actually built, appears in the center of the bottom photograph. The problem of the compatibility of Hardy's design with the street's existing architecture is one that surfaces in various forms for historic or architectural design commissions in cities throughout the United States. In rendering their decisions, these commissions must balance concerns for visual compatibility with the values associated with artistic freedom and, perhaps, constitutionally proscribed censorship of that freedom.

Icons and Aliens

something about architecture that sets it off from the other arts, denying it the protection they enjoy under the First Amendment?

Community pressures did not prevail in this case, perhaps because the landmarks commission was daunted by these troublesome questions. Not infrequently, however, policymakers rubber-stamp demands that imperil process values, leaving it to the courts to tell them whether or not they have overstepped their bounds. A wily former speaker of the New York Assembly explained the practice to me thusly: "The Legislature is not the Supreme Court; let it pass such measures as it wishes, and leave it to the judges to worry about their legality."

This reasoning runs counter to the lawmakers' proper role and to the practicalities of the situation. In their status as brokers between the community and the courts, lawmakers are the *only* ones who can translate and, when necessary, discipline raw community demands to ensure their compatibility with the process values safeguarded by the courts. Judges certainly can't perform this role. By the time an aesthetics measure comes before them, it is written in stone and can only be voted up or down. Also wide of the mark is the assumption that dubious measures will actually come before the courts. Mounting a lawsuit is so costly, time-consuming, and uncertain a venture that even the most questionable laws often go uncontested. For all practical purposes, what the lawmakers approve is the law, period.

Lawmakers must therefore endeavor to draft balanced directives, lest administrators improperly implement the legislative will. The task is rather like giving directions to a cleaning crew: if obscure, the crew becomes the arbiter of what to do and how to do it; but if every detail is exhausted, the crew finds itself hamstrung as it goes from room to room and task to task. Of the two alternatives, obscurity is the more troublesome. Laws imposing bans on new construction that is "incongruous to the historic aspects of [its] surroundings" or incompatible with a town's "atmosphere," to take two actual statutes,[27] leave administrators guessing. They puzzle judges as well and leave the legal process wide open to the excesses recorded earlier in this chapter.

Judges

Balance is no less a virtue for judges than for lawmakers. It is not the job of judges to veto the community's end-state values. But neither do they do their job by ignoring encroachments on process values. Early-period judges erred in the first direction. Fortunately, government-by-judges came to an end during the Roosevelt era. Since the 1930s judges have declined to substitute themselves for lawmakers as arbiters of the wisdom of social laws or for administrators as experts on the details of the laws' implementation.

Yet many modern judges have become so deferential that they decline to hold lawmakers' feet to the fire on the question of process values. Although speaking to a somewhat different issue, Frederick Hall, the twentieth century's premier land use jurist, encapsulated the state of the judicial mind on matters aesthetic in his endorsement of Norman Williams's complaint that "the leaders of liberal democratic thought are all too often so confused with abstractions . . . , so full of respect for local autonomy, and so fearful of judicial review generally as to be unable to understand the implications of what is going on."[28]

Administrators

How well administrators perform their job depends very much upon how well lawmakers and judges perform theirs. When lawmakers utter standardless mandates, administrators often make aesthetics policy themselves or in conjunction with influential community groups. When judges approve such delegations of legislative power, that policy becomes the law.

So we are faced with the question of balance once again. Administrators must be allowed latitude. Aesthetics standards are inherently difficult to define independently of the specific design problems they address. Municipal lawmakers, for example, may appreciate that their community contains a variety of distinctive neighborhoods that merit protection. Unless the lawmakers become administrators themselves, however, their role must center on defining a framework of preservation policies and procedures. Necessarily, it falls to administrators to flesh out both as they prepare the detailed staff studies that justify the lawmakers' action and proceed with the nitty-gritty of district administration. Surely we don't want judges to return to their pre-Roosevelt ways by vetoing lawmaker/administrator teamwork.

This, at least, is how it's supposed to work. Often it does not. Lawmakers have been known to seek political credit for nifty-sounding programs while avoiding association with the programs' financial and human costs. Aesthetics programs, as we have seen, may be both nifty-sounding *and* costly. The result: legislators basking in aspirational language, while avoiding the cost issues by sliding them over to administrators.

Icons and Aliens

Justice Hall's plaint sets the agenda for this chapter. What, indeed, is really going on in legal aesthetics disputes? Who are the contenders? What are they fighting over? What do they expect from the law?

Surprisingly little attention has been paid to these questions despite the decades-long debate about legal aesthetics' legitimacy and, more recently, the billions of dollars in public and private spending induced or hindered by the nation's diverse aesthetics programs. Fascination with the idea of beauty has proven hypnotic, leading to fruitless clashes over abstractions and to a conception of the environment as a collection of objects that legal aesthetics must grade, curator-like, on the basis of their formal qualities. Experience teaches otherwise, however. In legal aesthetics *people* come first; their emotional investment in environmental features, second; and the formal qualities of these objects, last. The aesthetics impulse springs from "the sense of self in a place," as Donald Appleyard advised. To ignore "self"—the human element—and fixate on "place"—environment as object—gets us off on the wrong foot entirely.

Simple observation can set things aright by revealing that aesthetics controversies share a common format centered on the opposition between icon and alien and their respective champions. Within that format, roles, predetermined and predictable, are parceled out to social and legal actors. Format and role are described in this chapter, which draws generously from the Rice Mansion and deli disputes as archetypes and, building upon this descriptive foundation, confirms that stability, not beauty, animates community demands for legal aesthetics.

A Format for Aesthetics Controversies

The mansion and deli disputes call to mind a quadrille in which the society partners its legal system, which in turn partners the society. In this case, however, the dancers within each file are openly

suspicious of one another and of the dancers across the floor. Yet the dance goes on because without it there would be no legal aesthetics.

We needn't delay at length over the partners in the legal file because their steps have already been rehearsed in the preceding chapter. It is enough to note that the role of lawmaker in both controversies was assigned to New York City's Board of Estimate; the city's landmarks commission appeared as administrator in both, assisted by the city's building department in the deli matter; and the state's judicial system was summoned to the set but did not actively participate in either controversy. Our attention focuses instead on the partners across the floor and their involvement with icons and aliens.

Icons and Their Champions

The mansion dispute featured two icons linked to overlapping constituencies. One was the Rice Mansion, which was backed by such landmarking groups as the Municipal Art Society, the Citizens Union, and, to the extent it was so motivated, by Board No. 7. The second icon was the West Side as a "solid, low-rise, low-key, family-type" neighborhood, championed by Board No. 7 and many local residents. Park Avenue was the icon of the deli flap, jointly defended by neighborhood activists, to whom Park Avenue is "an oasis of peace and safety in a crazy world," and by the Friends of the East Side Historic Districts.

All aesthetics controversies feature groups struggling to defend some common perception of a cherished icon under fire. Who the contenders will be varies with the icon in question. If the Statue of Liberty, just about everyone from corporate America to schoolchildren gets involved. If a county courthouse building or an elementary school, the constituencies are smaller and less well organized. Often, they seek strength through association with such stalwarts as the Sierra Club or the National Trust for Historic Preservation.

Icons, too, vary. So fertile is our capacity to forge bonds with the environmental features about us that *all* are potential icons. The Chicago Loop's El is an icon. So too are Lucy, the Margate (N.J.) Elephant; Los Angeles's Big Do-Nut Drive-In; the Goodyear Airdock in Summit, Ohio; and the nation's first McDonald's restaurant (Des Plaines, Illinois).

We bond to our icons for reassurance; and they, in turn, reinforce our sense of order in the world no less than religion or popular culture. An icon's loss or contamination is accompanied by reactions quite similar to those that, for many, accompanied the elimination of Latin from the Roman Catholic Mass, the death of Bing Crosby, Judy Garland or John Lennon, or even Coca-Cola's decision to change its "classic" formula.

Icons: A Study in Serendipity

Our capacity to invest the environment about us with myth, fantasy, fun, and awe is boundless. Boundless too are the environmental features that become icons. Who could predict iconage for the first McDonald's restaurant, titled in the 1950s "McDonald's Speedee Service Drive-In"? Or similar status, incredibly, for Goodyear's 55-million-cubic-foot airdock? Yet these and the other features portrayed here have been targeted in community preservation efforts.

"For heaven's sake, Martha, admit you're licked!"

Mourning the Icon's Loss

Icons are indeed a projection of the human mind and spirit, loved when they live and mourned when they die. Martha's refusal to admit she's licked is treated with humor in this cartoon. Underlying that humor, however, is the grim tension so evident in the faces of Joseph Papp and his associates at the demolition of Broadway's Morosco Theater.

Icons and Aliens

Predictably, bonds between people and icons prove especially compelling in times of stress and uncomprehended change. It is these bonds, for example, that cause immigrants and pioneers to name their new environments after the old; New England; New London, Connecticut, with its Thames River; and New York City, with its Little Italy.

When cities are destroyed by catastrophe, their citizens move quickly to restore them. Following World War II, the Poles' painstaking restoration of Old Warsaw and the venerable quarters of other Polish cities drained their national treasury and retarded reconstruction of their war-torn economy. I shall never forget watching Polish sculptors restore a huge marble horse that the Nazis had dynamited from its position atop a frieze on a Warsaw castle. Only a few shards from the horse's mane and rump remained from the original statue. The sculptors duplicated the horse and then, to my astonishment, inserted the shards at the precise positions they had occupied in the original.

Such obsessive restoration confirms Kevin Lynch's claims that the environment is a "vast mnemonic system for the retention of group history and ideals,"[1] and that "after a catastrophe, the restoration of the symbolic center of life is a matter of urgency [owing to the power of the] symbolic environment . . . to create a sense of stability. . . ."[2] Take, for example, the loss of a landmark such as Chicago's Old Stock Exchange or New York's Pennsylvania Station. It is often experienced by those bonded to it as if it were the loss of a beloved companion, prompting Norma Evenson's comment that buildings, like cities, "are a projection of the human mind and spirit; they are part of the human experience. They can be loved; they have a kind of life, and when they are destroyed it is a kind of death."[3]

Urban renewal also exposes the compelling ties that bind people to places. After Boston's West Enders were displaced by the clearance of their "slum" in the 1950s, they reportedly experienced an acute "grief reaction." Among its elements were "feelings of painful loss," "continued longing," a "general depressive tone," a "sense of helplessness," and "tendencies to idealize the lost place."[4] Then there is the reaction of South Bronx residents to the film *Fort Apache*, which portrays the area as an urban sink of drug dealers, prostitutes, and desolation: "They Call It Fort Apache; We Call It Home."[5] Surely Donald Appleyard got it right when he said that "the home environment, as it evolves with the modifications and adaptations that we make on it, becomes in some sense a part of ourselves."[6]

Revolution and protest, two of the most turbulent expressions of social change, reveal that the ties that bind people and icons can turn sour, evoking hatred, disgust, and shame where affection once reigned. In 1871 the Communards burned the Tuileries and toppled the Column of the Place Vendôme to vent their rage at France's

Royalist past. A century later, hordes of disaffected young Swiss, known simply as Movement, attacked the Zurich Opera House after a $38 million renovation plan was unveiled. As they smashed its ornate windows, they shrieked: "Everything for them, nothing for us!"; "Money for rock 'n' roll!"; and "Down with the theater of the elite!" "Movement wants to tear down the opera house," commented one observer, "[because] it sees [it] as a symbol of everything that is wrong in Switzerland."[7]

Discomfort with the associations of a building or setting may also cause people to oppose its preservation. In the 1930s, Parisians bitterly debated whether the Saint-Germain quarter should be preserved or leveled. One passionate opponent of preservation cried: "What crimes, history, one commits in your name. One ought, at least, to distinguish among the memories it leaves us. There are some it is better to forget. It is impossible to traverse the narrow streets which go from the Quai de Conti to the old abbey of Saint-Germain-des-Prés without seeing again the horrible days of the revolution of which they were the theaters, where the walls themselves have retained the cries of the victims of September, and where . . . blood flowed like a river."[8] More recently, New Yorkers found themselves ambivalent about honoring the Tweed Courthouse with landmark status since its construction added millions in boodle to the pockets of Boss Tweed and his cronies.

Sometimes the Bulldozer Is a Friend

When their message is painful, buildings may be hated rather than loved. A case in point is the McDonald's restaurant in San Ysidro, California, where a crazed gunman killed twenty-one people in July 1984. In this photo the restaurant is being razed, the McDonald Corporation's response to a petition signed by 24,000 people urging that the site be used as a memorial park honoring the victims.

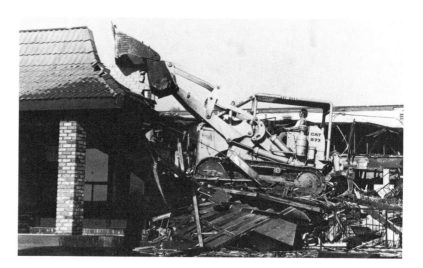

Icons and Aliens

But these are the exceptional cases. Usually, time so mesmerizes later generations that they preserve distinctive settings and places whose associations clash with current political, social, or moral beliefs. The Indonesians, for example, have worshipfully maintained the colonial houses of their former Dutch rulers. The Soviets do the same with the palaces and churches, not to mention the ballet and music, of czarist Russia. Significantly, the Tweed Courthouse was eventually designated a historic landmark. Perhaps time's rosy haze also explains why a number of former whorehouses have become landmarks in this country.

Aliens and Their Champions

Sitting across the seesaw from icon supporters are constituencies promoting aliens, which may either displace icons (thirty-story tower vs. Rice Mansion) or coexist with them in a relationship that infuriates icon supporters (zucchini vs. Park Avenue; "East Side building" vs. the West Side). Private developers and entrepreneurs are the most visible and hissed-at group, as the yeshiva's frustrated tower builder and Mr. Choi discovered. But government itself cannot be ignored because public agencies promote environmental change even more actively. Robert Moses's eagerness to run an elevated highway through Greenwich Village's Washington Square or the Federal Power Commission's indifference to the aesthetics impact of a pump storage plant on Storm King Mountain certainly outstrip Donald Trump's furtive trashing of the Art Deco friezes of Fifth Avenue's now-demolished Bonwit Teller Building. Although late in coming, recognition of this fact explains in part the passage of the aesthetics environmental laws of the 1970s.

Also engaged are groups who benefit from the alien's descent or from the advantages they receive once it has landed. Labor unions, banks, building materials manufacturers, and other suppliers of real estate services and products have a direct financial stake in hosting these extraterrestrials. Other likely members of the welcoming committee are consumers of the alien's products or services: future residents of the yeshiva's high rise, for example, or purchasers of Mr. Choi's comestibles. Support may be forthcoming as well from residents of subdivision housing built on once-virgin, scenic land, customers of utilities seeking to provide cheaper power by building on the Storm King Mountains of the nation, or students or patients of universities or hospitals that plan to expand their facilities into surrounding neighborhoods.

Aliens are not easily pinpointed in advance. Sure, the West Side's opposition to high rises was predictable, but who would have dreamed that *vegetables* would put the East Side's nose out of joint? Or that sodium vapor streetlights would do the same in upper-class Bronxville (N.Y.) because, to its outraged citizenry, these fixtures belong

Development: The Wolf at the Door

Icons are beset by various predators, war and natural calamities among them. The most maligned of these, however, is the developer, often viewed as greedy, insensitive, and, above all, powerful. The developer's depredations, it is feared, threaten the loss of collective identity through the destruction of neighborhoods or entire cities. The question is more complicated, of course. Some developers are as portrayed here, and legal aesthetics regimes are a necessary antidote. But developers are also agents of desirable social and economic change, responding to broader social needs. There is, in addition, the irony that many features we now view as icons were built by earlier generations of developers and were seen then as aliens.

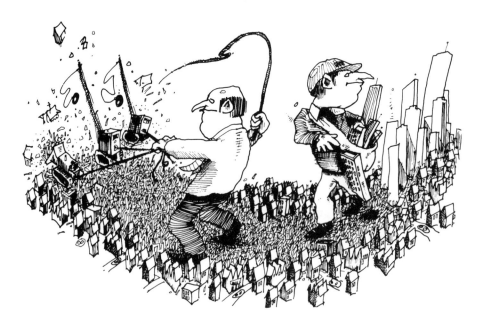

in penitentiaries or along interstate highway exchanges, *not* in Bronxville's downtown? Or that lettered workmen's vans parked in front yards in lower middle-class River Edge (N.J.) would be banned by an irate city council, fearful that River Edge might get tagged with a beer and T-shirt image?

Tastemakers

Because aesthetics germinates within the society, its tendrils only later reaching into the law, tastemakers merit our attention. By contributing to our images of the environment, they influence community attitudes, which furnish the raw material for aesthetics policy. When disputes arise subsequently, their voice is respected by the general public and by lawmakers, administrators, and judges. Mandarins endowed with a technical vocabulary, they can reach key audiences at key points both in the formulation of aesthetics policy and in the resolution of particular battles.

Prominent among the tastemakers are three classes of commentators. There are the media critics, such as the *New York Times*'s Ada Louise Huxtable or Paul Goldberger or the *Washington Post*'s Wolf Von Eckardt. Critics' columns appear frequently, enabling them to zero in on newsworthy disputes or to press favored themes over longer periods of time. Goldberger's pro-designation column, which appeared shortly before the Board of Estimate's decision in the mansion dispute, boosted Board No. 7's case. The continuing barrage fired from the Sunday column of the *Times*'s former architecture critic, Ada Louise Huxtable, had New York developers, politicians, and bureaucrats ducking for years.

A second group, in which a Lewis Mumford, Jane Jacobs, or Kevin Lynch fits comfortably, takes a longer view of aesthetics issues, publishing in increments of years, not of weeks. It explores fundamental themes and patterns, not newsworthy topics that can be squeezed into a series of columns for the casual reader. Despite this group's smaller, more technically inclined audience, its influence is often more durable. Urban renewal, for example, has yet to recover from the all-out assault on mega-planning launched in Jacobs's *The Death and Life of Great American Cities* (1961).

Architects, urban designers, and others who double as publicists for their creations comprise another group of tastemakers. Louis Sullivan, Frank Lloyd Wright, Le Corbusier, Philip Johnson, and Robert Venturi are among these two-hatters. As designers they shape images that debut as aliens and, with time, struggle, and luck, may end up as icons. The tower-plaza building that so troubled the West Siders, for example, harks back to the "tower in the park" of Le Corbusier, who assailed New York City's pre-1961 zoning code because it vetoed this configuration. As publicists they find themselves caught in the squeeze between the instinct for creativity native to

"Ada Louise Huxtable already doesn't like it!"

The Role of the Critic

Icons and aliens are creations of mind and attitude. One important source shaping our perception of both is the critic: the publicist for aesthetics causes and, often, the "expert witness" in legal aesthetics conflicts. The critic's contributions on both fronts can afford valuable guidance for the social and legal systems provided that criticism takes into account the nuances differentiating museum from legal aesthetics.

their craft and the anxious conservatism of groups fearful of environmental change.

Finally, there are the activist organizations and individuals who lobby or support public relations efforts targeted at securing legislation or specific decisions favorable to the preservation of icons. Participants may include such groups as the Sierra Club, the National Trust for Historic Preservation, or the Municipal Art Society, or such celebrities as Itzhak Perlman, Jackie Onassis, or *The New Yorker's* Brendan Gill.

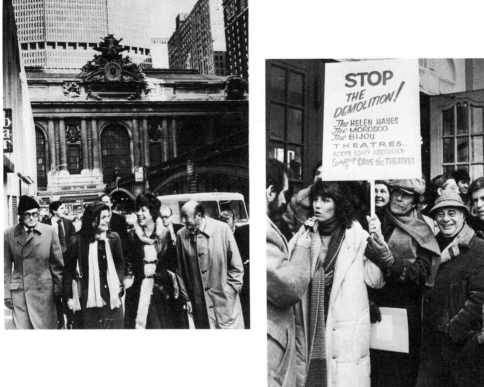

Jack Manning/NYT Pictures

Preservation and Public Relations

Public support is indispensable to the success of the nation's aesthetically oriented public programs. Perhaps nowhere have their proponents become as skillful in the conduct of education and public relations efforts as in New York City. Enrolled in the effort have been such prestigious publications as the *New York Times* and *The New Yorker* as well as celebrities from the worlds of art, theater, politics, and commerce. The Grand Central Terminal was preserved, thanks in no small part to the efforts of Philip Johnson, Jackie Onassis, Bess Myerson, and Edward Koch (above, left). Less successful was the campaign to preserve the Helen Hayes, Morosco, and Bijou theaters (demolished to make way for a Portman-designed Times Square hotel), despite the opposition of Lucie Arnaz, Lawrence Luckinbill, Martin Balsam, and Tony Roberts (above, right).

Icons *and* Aliens

An icon is an icon all by itself. An alien becomes such only in relation to an icon with which it is paired. What makes the types of aesthetics controversies with which law deals controversial is the tension between the two: the icon already there and the invading alien. Our two case studies furnish evidence of the shock generated by the repugnance of paired icons and aliens: killer vegetables (alien) menacing Park Avenue, an "oasis of peace and quiet in a crazy

Icons and Aliens

We hold America together.

Talon, Inc. 626 Arch Street, Meadville, PA 16335

Associational Dissonance: Two Views

We experience associational dissonance when conflicting meanings or values are combined. The device is frequently used in advertising, filmmaking, and other visual media to seize the viewer's attention, as in this Talon zipper/Statue of Liberty advertisement. It occurs in the built and natural environments with the pairing of icons and aliens, illustrated by billboards along a scenic vista. Attention takes the form of upset at the contamination of the icon's meanings by the alien's antithetical messages and, not infrequently, leads to the establishment of aesthetics regimes to bar the alien (e.g., eliminate billboards from highways) or to reduce the dissonance (e.g., permit billboards only within industrial zones along the highway).

world" (icon); glitzy tower as "East Side building" (alien) commencing its crosstown march to upend the "solid, low-rise, low-key, family-type" West Side neighborhood (icon); and tower as file cabinet, ant heap, impersonal modern architecture (alien) pouncing on Belle Époque–Neo-Georgian–Neoclassical confection, champagne-and-robber-baron Rice Mansion (icon).

Other paired icons and aliens are readily culled from court reports of the last quarter-century's battles. Illustrative are a pump storage plant (alien) scarring the Hudson Valley's Storm King Mountain (icon); a 307-foot tourist tower (alien) desecrating the Gettysburg National Cemetery (icon); a strapping office complex (alien) soaring above and demeaning the nation's Capitol (icon); power transmission lines (alien) contaminating the view across New Haven Bay (icon); and Marcel Breuer's hard-edged, fifty-two-story tower (alien) heckling the Beaux Arts Grand Central Terminal (icon).

Icons clash with aliens because the associations bonding an icon to its champions fail to jibe with those imputed to the alien, a relationship I earlier labeled "associational dissonance." This relationship arises because icons are both physical entities—the Rice Mansion as a structure, for example—and repositories of meanings imputed to them by their champions—the Rice Mansion as a landmark. Icons are both signifiers *and* the message they signify.

Aliens menace icons either by obliterating the icon's message altogether or by contaminating it. Obliteration, of course, destroys the soul by destroying the body. When Hitler asked, "Is Paris burning?" the Paris he had in mind was not a complex of buildings as such but the associations resident in them—the Paris of French culture and of former French military prowess over Germany. More

often, aliens leave the icon intact but contaminate its message by the dissonance of their own. Illustrative of this uneasy coexistence are "East Side buildings" on the West Side, delis on Park Avenue, sodium vapor lamps in Bronxville, and lettered workmen's vans in River Edge.

Let me hasten to acknowledge that associational dissonance is generally—in fact, almost always—mixed with other irritants in aesthetics controversies. How we use land, economists rightly remind us, may create physical as well as symbolic externalities. Recall that the West Siders feared the yeshiva's high rise would create congestion as well as contaminate their life-style. I focus here on symbolic externalities only because my present purpose is to isolate the "aesthetics" factor in land use control.

Icons always precede the legal regime that shelters them. Law created neither the mansion nor the distinctive ambience of the West Side or Park Avenue, nor, more to the point, the powerful bonds between these icons and their constituencies. Law entered the picture only when summoned by these constituencies, who feared their icons' loss to the attacking aliens. But the law can establish a forward defense against aliens once an icon is in place and recognized as such. An alien is an alien only in relation to its paired icon. Thus, a profile of the icon's character affords a framework for identifying aliens even in advance of their appearance because the aesthetics regime's focus is the dissonance between the two. The standards employed in aesthetics regimes to defend against aliens confirm this relationship. Invariably, they proceed from a profile of the icon's distinguishing characteristics, and their purpose, as routinely expressed in statute, is to ensure that new development will be "harmonious," "compatible," or "in character with" the icon.

My reasoning can be analogized to Christopher Alexander's treatment of the terms "fitness" and "unfitness" in the field of design. He posits that good design, or, as he puts it, "good fit," can never be defined abstractly or affirmatively because the variables accounting for it are too numerous. But good fit can be negatively defined by identifying elements that harmonize with the context in which the design problem arises. Whether a design is a fit or a misfit, therefore, can be determined by evaluating its compatibility with the context in which it is intended to function. "Even in everyday life," Alexander observes, "the concept of good fit, though positive in meaning, seems very largely to feed on negative instances; it is the aspects of our lives which are . . . incongruous . . . or out of tune that catch our attention."[9]

Much the same can be said about the selection problem that icons and aliens pose. The law cannot identify icons in advance of their appearance in the culture, serendipity not being its strong suit. Once the culture has done its work, however, the icon—Park Avenue or the West Side, let us say—becomes both identifiable and the "con-

text" against which fitness or unfitness of new development is gauged. Aliens, of course, are "misfits." Vegetables and twenty-four-hour take-out delis simply don't "fit" on Park Avenue, just as "East Side buildings" don't "fit" on the West Side.

Although paired with icons, aliens are by no means their equal before the law. The yeshiva's tower proposal was defeated because, like Thetis's immersion of Achilles in the River Styx, New York City's landmarks law enveloped the mansion in a shroud of invincibility. The subordination of aliens to icons is what the legal subsidy for

Fit and Misfit

Christopher Alexander's distinction between "fit" and "misfit" comes through clearly in this protest of the Pennsylvania Supreme Court's refusal to block the erection of a 307-foot, privately owned observation tower at Gettysburg, the site of the pivotal battle of the Civil War. The dissonance between the tower (alien) and the site (icon) is, of course, founded on clashing associations—the tower's crass commercialism defiling the burial ground's sacred and patriotic character.

aesthetics is all about, of course. It is government's finger on the scale, tipping it in favor of the icon. With the subsidy, the icon's friends can vaporize the alien, as they did the yeshiva's tower, or they can sue for an acceptable peace, as they did by inducing Mr. Choi to transform his deli into the Park 75 Gourmet Food Store.

Take the subsidy away, however, and the icon's friends have to contend with the less certain and more costly demands of the marketplace. Offering the yeshiva a higher price to preserve the mansion than the developer was willing to pay to demolish it would be one route. Another might be persuading the yeshiva to "do the right thing," at its own expense but for the benefit of others, never an easy task. A third might be to convince the alien's sponsor that the right thing, happily, is also the most profitable thing. Although foreclosed in the mansion dispute, this strategy or something very much like it may have induced Choi's last-minute flip on his deli.

The Aesthetics Impulse: Beauty as a Nonstarter

My view of what's really going on in legal aesthetics is obviously worlds apart from one positing that icons are protected because they are "beautiful," while aliens are scorned because they are "ugly." Aesthetics, this second view insists, connotes the pleasure or offense we experience in consequence of an environmental feature's formal visual characteristics. The view is seductive because we are all lovers of beauty. But resist it we must, because in misstating the case it creates false expectations of what the law can and should be doing on the aesthetics front.

Of this view's many flaws, three engage our attention. One is its undue emphasis upon sensory considerations at the expense of intellectual and cultural factors. Our minds are not blotters, passively receiving the environment's messages through sensory conduits. On the contrary, we actively shape what we "see" by investing the environment with all manner of meanings. Also, the beauty approach errs by assuming that the formal canons of the Academy determine whether environmental features are experienced as pleasurable or offensive. Jane Jacobs's encapsulation of this flaw is crisp and persuasive: "To approach a city, or even a city neighborhood, as if it were a larger architectural problem, capable of being given order by converting it into a disciplined work of art, is to make the mistake of attempting to substitute art for life."[10] And finally, the approach misconceives the referents of the terms "beautiful" and "ugly." Beauty or ugliness is not a property of an environmental feature taken by itself. Recall that legal aesthetics is people-, not object-, centered. It makes a great deal more sense, therefore, to view these terms as expressing emotional reactions triggered by messages broadcast to us by the environment's icons and aliens.

60

Icons and Aliens

Sensory Fallacy

The beauty approach improperly stresses the senses, particularly the sense of sight, an imbalance contributed to by the dead hand of the past. Back in 1735, Alexander Baumgartner defined aesthetics as the science of "sensory cognition."[11] Edmund Burke chipped in shortly thereafter with his definition of beauty as "some quality in bodies, acting mechanically upon the human mind by the intervention of the senses."[12] So dominant is the assumed linkage between aesthetics and the sense of sight that many legal theorists and judges assume that legal aesthetics' sole audience is sighted persons or, as a leading opinion puts it, persons of "average visual sensibilities."[13] While linking aesthetics to the sense of sight is unobjectionable as far as it goes, it hardly goes very far. *All* of the senses are engaged by the environment, as a stroll through New Orleans's Vieux Carré or a dash through New York City's Grand Central Terminal confirms. Raucous vendors' cries or shrieking brakes, the smell of freshly baked *beignets* or hot pretzels, and the tactile promptings of rough brick facades or sinuous marble tracery shape our responses to these icons no less than their Creole or Beaux Arts visual form.

The environment-as-sensorium approach tells only the less informative part of the story. Whether in the museum or beyond its walls, we respond not merely to an object's sensuous qualities but to its symbolic ones as well—the *meanings* we ascribe to it. Take away thought, feeling, and cultural affiliation and these meanings simply wouldn't be there. Susanne Langer grasps what Baumgartner and Burke did not when she advises that art "is not sensuously pleasing and *also* symbolic; the sensuous quality is in the service of its [symbolic] import."[14] Likewise, modern psychology rejects Burke's "bucket theory" of the mind, which treats human perception as a passive process, in favor of a "searchlight theory," in which intellect and feelings actively shape what and how we "see." Grady Clay reflects this view when he states that "a city is not as we perceive it by vision alone, but by insight, memory, movement, emotion and language. A city is also what we call it and becomes as we describe it."[15]

Formalistic Fallacy

The beauty school also talks as though there were canons of aesthetics waiting to be plucked from nature and plugged into the law. Thanks to these canons, it is thought, the law has both a recipe for creating new forms of environmental beauty and a checklist for selecting which among the existing forms should be singled out for preservation on the basis of its beauty.

This illusion has had its defenders over the ages. From Pythagoras on, mathematicians have searched for universal laws of beauty that

could be expressed as number and interval. Followers of the French mathematician/philosopher Descartes believed that such laws could be deduced from something called "pure reason." "Every art," one Cartesian propounded, "has certain rules which by infallible means lead to the ends proposed."[16] Others spoke of "universal" canons by generalizing from some style that enjoyed the favor of tradition or despot. Before 1750, for example, architectural beauty in the West was generally regarded as a harmonious system based on abstract mathematical intervals and analogies to the proportions of the human body. Leon Battista Alberti, the system's Renaissance codifier, was so confident that this system provided beauty's key that he preached of beauty as a "harmony of all the parts," such that "nothing could be added, diminished, or altered, but for the worse."[17]

However expressed, the beauty premise is seductive. As individuals, we do experience icons and aliens as pleasurable or offensive, and we do describe them by their visual characteristics. While our individual reactions often coincide with broader patterns of group or community response, the conclusion that these patterns can be explained by formal canons of beauty is plagued with insuperable obstacles.

The Frustrating Search for Standards

Most daunting, of course, is that no one has succeeded in defining these elusive canons despite centuries of trying. With refreshing if anguished candor, Albrecht Dürer, himself a champion of Formalism, confessed: "What beauty is I know not, but it dependeth upon many things."[18] Although the conventions of particular styles can be formulated, no single style can serve as beauty's model. "There is no art in which there is only a single tradition," John Dewey has warned. "The critic who is not intimately aware of a variety of traditions is of necessity limited, and his criticisms will be one-sided to the point of distortion."[19]

Unable to agree on first principles, design critics violently dispute the merits of particular styles, features, and settings. To Ada Louise Huxtable, the New York Public Library is "one of the last of the great nineteenth-century buildings."[20] But for Lewis Mumford it gasps with the "hollow echoes of expiring breath."[21] The crisply standardized street walls, cornices, and building facades of Baron Haussmann's Paris, which so delight tourists and Parisians alike, exasperated Camillo Sitte. "Why," he complained, "must the straight-edge and the compass be the all powerful masters of city building?"[22] New York City's gridiron street system is cursed by many thoughtful urbanists as a monument to execrable planning and greedy real estate speculation. Yet Paul Goldberger extols its "neat, tight, ramrod-straight views that stretch from river to river."[23] Le Corbusier added that it is a "model of wisdom and greatness of vision."[24] In Edith Wharton's eyes, the city's brownstones, today the pride of many of

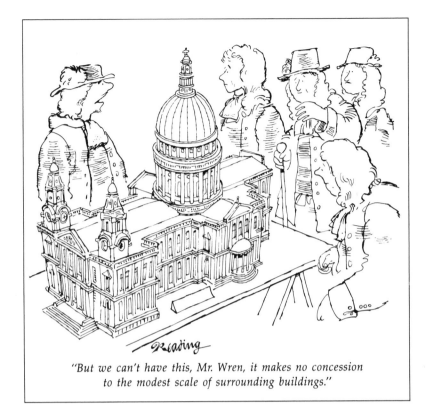

"But we can't have this, Mr. Wren, it makes no concession
to the modest scale of surrounding buildings."

Design by Formula?

This imagined response of London's design authorities to Wren's proposal for St. Paul's Cathedral parallels the disagreements among the critics of urban design and architecture quoted in the text.

its historic districts, were loathsome buildings clad in "chocolate-coloured coating of the most hideous stone ever quarried [and set within a] cramped, horizontal gridiron of a town . . . hide-bound in its deadly uniformity of mean ugliness."[25]

The warfare now raging between neoclassicists and postmodernists in one camp and modernists in the other exemplifies even broader differences over what our cities should look like. Neoclassicists, who favored Beaux Arts urban design and architectural styles, held sway at the turn of the twentieth century but lost the field to modernists over the next fifty years or so. Regrouped under the postmodern banner, they are now counterattacking in cities as distant as Paris and San Francisco. Nirvana to them is elaborate ornamentation, masonry construction, uniform street walls, contextual buildings, and architectural eclecticism. Modernists see things differently, however. They champion monumental buildings standing aloof from their surroundings, irregular street walls, lean ornamentation, and diversity in building technologies and materials.

"It's too pointy."

Time and Taste

Time plays tricks on taste. "Ugly" buildings do indeed survive to become "interesting" and eventually "beautiful," as Norma Evenson comments. Here, two cartoonists add a trick of their own by reversing time's flow so that we, millennia later, can eavesdrop on contemporaneous responses to structures cherished today as icons.

Time also enters the picture, for one generation's alien is the next's icon. Over time, Norma Evenson correctly advises, "the 'ugly' building may survive to become 'interesting' or 'amusing,' and finally 'beautiful.' What was once deemed 'monotonous and mechanical' may later be seen as 'harmonious and orderly,' and the 'excessive and vulgar' become 'imaginative and vital.' "[26] Take the case of the Eiffel Tower. Prior to its erection in 1899 and its planned demolition twenty years later, it was scorned as the "dishonor of Paris" by Gounod, Prudhomme, and other members of the Committee of Three Hundred (one member per meter of the tower's height). Implored the group: "Is Paris going to be associated with the grotesque mercantile imaginings of a constructor of machines . . . ?" Yet the tower still stands, now as the beloved signature of the Parisian skyline and an officially designated monument to boot.

The dogmatism of earlier aesthetics thought has softened with its recurring failure to discover beauty's secrets, whether through philosophical discourse or experimental psychology. Aestheticians since Kant, in fact, have largely abandoned the premise that beauty exists in the concordance between formal canons and an object's visual qualities. Instead they think of beauty as the outcome of an exchange, emotional in nature, between artist and audience. Roger Fry, an influential English critic of the first-third of the twentieth century, speaks for this group in his confession that the search for the "criteria

Icons and Aliens

"Terrific! Really great! I love it! Everybody in Athens loves it!"

of the beautiful, whether in art or in nature . . . always . . . led to a tangle of contradictions or else to metaphysical ideas so vague as to be inapplicable to concrete cases." The more profitable route, he advises, must begin with the idea that "a work of art [is] not the record of beauty already existent elsewhere, but the expression of an emotion felt by the artist and conveyed to the spectator."[27]

The most persuasive case against a rule-bound aesthetics of beauty is framed by Susanne Langer's admonition that rules "are not criteria of excellence; they are explanations of it. . . . As soon as they are generalized and used as measures of achievement they become baneful."[28] Creative artists agree. Louis Sullivan counsels that "all mechanical theories of art are vanity, and . . . the best of rules are but as flowers planted over the graves of prodigious impulses which splendidly lived their lives, and passed away with the the individual man who possessed these impulses. . . . it is within the souls of individual men that art reaches culminations."[29] Siegfried Giedion completes the case with his testimony that the creative impulse has "grow[n] only in liberty, for no command can open the way to the unexplored."[30]

Icons and Aliens

The Museum/Courthouse Confusion

Beauty talk confuses the museum with the courtroom. Recall one judge's concern that to admit aesthetics into the law would force the law to choose between jazz and Beethoven, posters and Rembrandt, or limericks and Keats. In truth, the aesthetics preferences woven into the decision to preserve the San Francisco Bay or the New Jersey Pine Barrens are of a different order entirely, one neither as complex nor as refined as those employed by museum curators,

Icons: Associations or Beauty?

Beauty has many definitions in formal aesthetics theory, all of them controversial. Its mysteries are inaccessible to the law, which needn't seek to explain them in any event because legal aesthetics' impulse proceeds not from an icon's beauty but from its contribution to our sense of identity and stability through the bonds that have linked us to it over time. Chicago's Water Tower is an icon not because of its unusual architecture but because it survived the Great Fire of 1871.

concertmasters, or Pulitzer Prize judges. Even cruder still are the gauges registering opposition to front yard clotheslines in exclusive residential neighborhoods, billboards along scenic highways, or unfenced junkyards on a community's outskirts.

Does the gap between museum and legal aesthetics close in the case of landmark buildings and historic districts? I think not. Many of these icons are not even described as "beautiful" by their supporters. Illustrative are Chicago's landmarked Water Tower, a Disneyesque parody of a turreted castle erected to cloak the waterworks and standpipes hidden within, and New York City's Greenwich Village Historic District, aptly described by one commentator as an "architectural melange."[31] Explaining the designations are powerful associational bonds between these icons and community groups, not the icon's supposed beauty. Chicagoans cherish the Water Tower because it was one of the few buildings on the city's North Side to survive the Great Fire of 1871. New Yorkers, who are largely indifferent to the Village's architecture, treasure the Village for its indelible associations as a center of bohemian artistic life comparable to Paris's Left Bank.

What then of buildings and districts exemplifying some well-known style, be it Gothic, Renaissance, or Victorian? No doubt these icons are "beautiful" to those favoring these styles. But the refinement of the Academy is too thin a reed for a legal regime because most people are indifferent to these refinements as such. Style *is* important but for a different, if less erudite, reason: it evokes associations that go back for generations or centuries, stimulating imagination, fantasy, and, not infrequently, specious romanticism in the community mind.

Walter Kidney goes to the heart of the matter in his study of eclecticism in American architecture from 1880 to 1930. The enthusiasm with which Americans built eclectically, he asserts, sprang from the linkage between the styles selected and "historical associations that every cultured person was [then] familiar with." "When style was thus determined," Kidney continues,

> a house was usually Georgian, Tudor, or Cotswold (Anglo-Saxon home atmosphere), unless it was a mansion and intended to look like one in which case it might have been Jacobean or one of the Louis (aristocracy of wealth). A church—if colonial—would, for an old and ritualistic sect, be Gothic (Christian heritage); if it was for some new sect, like the Christian Scientists, it might be decently but noncommittally wrapped in something classical. A synagogue, in the absence of a true Hebraic architecture, was usually Byzantine or Moorish. . . . A school was Tudor or Jacobean (Oxford, Eton). A theater was either Louis XV (courtly diversions) or—especially if a movie house—something utterly fantastic, with some sort of high-pressure Mediterranean Baroque providing the norm (palace of illusions). For the center city, classicism was long the near-universal solution; a cluster of styles, rather than a single style, it clothed the museum, the library, the memorial structure in cool

eternal beauty, but broke into rustications, ressaults, and swags, giant orders and Renaissance cornices for the more worldly office buildings, the bank, the apartment house, the theater, the clubhouse, and the town mansion.[32]

A better core catalog of the types of buildings now on the agenda of every landmarks commission in the United States cannot be found.

The Creation/Conservation Confusion

Faith that beauty can be made to answer to abstract rules of visual form slides easily into the misconception that the law can employ these rules to create a beautiful environment. Such reasoning places the cart before the horse, however. Conservation, not creativity, is legal aesthetics' province. What is being conserved, of course, is the icon, which comes to the law's attention only *after* it has achieved that status in the community's mind. Legal aesthetics' criteria, we have seen, are plaster casts of icons, their purpose being to ensure that new development "fits" with these icons. They seldom, if ever, create original forms because their office is to mimic or safeguard forms that already exist.

Semantic Fallacy

The terms "beautiful" and "ugly" are often used to describe an environmental feature as though it were an isolated object ("That billboard is ugly") or to characterize the object's *visual* relationship with some other feature or ensemble ("The yeshiva's tower is 'too big' for the West Side"). For legal aesthetics purposes, however, the first usage is incorrect and the second, incomplete. An icon's appeal or an alien's offensiveness is not invariable, as the first usage demands. "Everything in this world," Rudolph Arnheim properly advises, "presents itself in context and is modulated by that context."[33] And, as we have seen, icons afford the context for aliens. Outrageous (to some) on Park Avenue, Mr. Choi's zucchini and okra would have fit "beautifully" in a stall along Greenwich Village's Bleeker Street. Likewise, buildings that postmodernists concede to be spectacular architecture in themselves offend when jammed into inappropriate settings.

The second usage is too narrowly focused. Visual relationships among environmental features are significant, of course, particularly for those sophisticated in architecture or urban design. Legal aesthetics' audience in a democracy, however, is John and Jane Q. Public, not the aesthetically refined. Associational relationships take precedence over visual relationships in the general public's mind. It isn't an alien's failure to respect the canons of a Ruskin or Vitruvius that causes citizens to curse icons in the language of rape, blasphemy, and death. And neither do these canons cement the citizenry's bonds with icons.

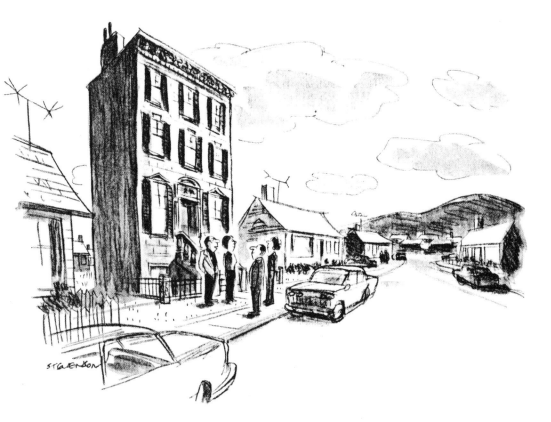

*"We always wanted a brownstone, but prices were sky-high,
so we decided to move out of the city and build."*

Context: The Framework for Perception

Set between flanking brownstones in a New York City neighborhood, the
brownstone featured here would fit neatly. Transported to suburbia, it seems
oddly out of place, because, as Rudolph Arnheim comments, "everything
in this world presents itself in context and is modulated by that context."
Neither context nor foreground is described by visual characteristics alone,
however. Both are permeated as well by networks of meanings that have
come to be associated with them over time. Aesthetics regimes are called
into play when the context is an icon and the foreground an alien. Strikingly,
features that are icons in one setting may be aliens in others—the source
of humor in this cartoon.

Illustrative is a 1979 lawsuit brought by the United States Secretary
of the Interior to block construction of a group of office towers across
the Potomac from, and soaring above, the nation's Capitol. "Mon-
sters that would visually deface the skyline surrounding the national
monuments," the secretary cried, "an aesthetic nuisance."[34] Was his
objection solely or even primarily that the towers were "too big,"
considered in terms of their stereometric relation to the Capitol? I
think not. By parity of reasoning, the Washington Monument would

"visually deface" the White House, yet obviously no American "sees" the monument that way. What distressed the secretary was that speculatively built commercial towers dwarfing the Capitol presented as shocking a case of associational dissonance as would construction in medieval times of a governmental or private building overwhelming the town's cathedral. One of the secretary's witnesses got it right in testifying that the towers would "interfere with the perception of the general visitor to Washington . . . in terms of [that city's] historic role . . . as a pilgrimage site for the great national memorials of this Nation."[35]

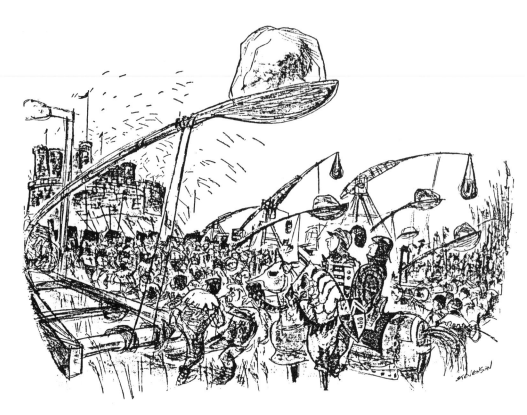

"In a way, I hate to do it. That's one of the finest examples of twelfth-century fortified Norman."

Museum versus Legal Aesthetics

This cartoonist's warrior knight, we can surmise, doubles as an architectural historian in peacetime. His qualms about destroying the Norman castle center on its formal aesthetics qualities. More than likely, however, the castle hosts values of a different order for the beseiged villagers within, values akin to those possessed by the dynamited Warsaw castle discussed at the outset of this chapter. It is one thing to admire a structure as exemplary architecture and quite another to experience it as an anchor of individual or collective identity. The difference between the two is, at root, the difference between museum and legal aesthetics.

Aesthetics and Process Values

Unions founder when spouses are unable to talk to each other. Sometimes, spouses do not understand their needs well enough to articulate them; or if they do, they may lack the common vocabulary necessary for communication. In such instances the marriage counselor must assist the individual spouses to surface their needs and then must get them talking to each other in a language that both understand. I have been proceeding in similar fashion with the troubled law/aesthetics merger. The constraints experienced by law in responding to the aesthetics impulse were introduced in chapter 2, and the impulse's social basis was explored in chapter 3. This chapter seeks to bring the two together by suggesting directions for reconciling the tensions between legal aesthetics' end-state values (those deriving sources outside the law) and its process values (those inherent in law itself).

Legal Language and Lay Language

The legal system, which has problems enough understanding the language in which social demands are cast, responds in a lexicon more opaque still. If communication is to flow both ways, then translation is necessary and a common vocabulary must be forged. But translation from the legal side is hampered by the law's penchant for divvying up concerns that are inseparable to the nonlegal eye and packaging them in a series of puzzlingly labeled boxes that seem remote to the problem at hand. "If you can think about something that is inextricably attached to something else without thinking about that thing," goes the axiom, "then you can think like a lawyer."[1]

What better example than this volume's major headache: legal aesthetics' incoherence. When stated in lay language, the process value issues it poses are easily grasped. Incoherence leaves us in the dark concerning what public purpose the venture serves, what it demands of regulators and the regulated, whether it is veiled gov-

ernmental censorship, and who, as between icon owners and the rest of us, should bear its costs. But the law translates these issues into a language of its own. Among the legalisms that parallel these concerns, it turns out, are "substantive due process" (legal aesthetics' purpose), "separation of powers" and "void for vagueness" (obligations of the regulators to one another and to the regulated), "restraints on expression unsupported by a substantial state interest" (governmental censorship), and "uncompensated takings" (unfair cost allocation). Despite their intimidating ring, these legalisms needn't block communication. Each expresses values that, in fact, are familiar to us all, as the following vignettes illustrate.

"Substantive Due Process"; or "Should Government Be Doing This in the First Place?"

"The owners of the Boston Garden want the 60-year-old arena put on the National Register of Historic Places so they can get a 25 percent tax break on rehabilitating it . . . ," states an Associated Press dispatch of April 17, 1985. Continuing, it quotes the Massachusetts secretary of state: "They're claiming the Garden represents Boston sports history, with all the championship banners and lore of the Celtics and Bruins."[2]

Now the Boston Garden means as much to me as to anyone. As a youngster growing up just outside Boston, I remember watching Bob Cousy and Bill Sharman work their magic for the Celtics and, less happily, going limp as Carmen Basilio TKO'ed Tony De Marco, my brother-in-law, in the thirteenth round of 1957's "Fight of the Year." But I have to admit that the AP dispatch exposes a troublesome ambiguity. Is it saying that the Garden should be landmarked to confer a tax windfall on its owners? Or that it should be landmarked because it is an icon?

On the legal side, these questions present themselves as end-state and process value issues. The end-state issue, which lawmakers must resolve, is whether the Boston Garden merits designation as a landmark. The process issue, which falls to judges, is two-part: whether the purpose behind landmarking is a legitimate concern of government and, if so, whether landmarking is a reasonable means for achieving this purpose. This ends/means test reflects the two prongs of the substantive due process doctrine, which must be satisfied by all public programs, aesthetics-driven or not.

"Separation of Powers" and "Void for Vagueness"; or "How in the World Are We to Behave If We Can't Figure Out What the Law Expects of Us?"

Allegations of unfairness, "landmarking by ambush," and misuse of landmarks procedures for zoning purposes cast a pall over the

1985 designation of New York City's Coty and Rizzoli buildings, located on Fifth Avenue diagonally across from the site of Donald Trump's sixty-eight-story Trump Tower. Back in 1966 and again in 1981 and 1983, the city's landmarks commission had considered naming the Rizzoli Building a landmark but declined to do so. It had ignored the adjoining Coty Building altogether. Encouraged by eighteen years of commission inaction, a subsidiary of the First Boston Corporation assembled a site that included the Rizzoli and Coty buildings at a reported cost of $86 million, or a staggering $4,000 per square foot.

The office building that First Boston proposed for the site satisfied pertinent zoning requirements. Nonetheless, it proved objectionable to the strangest of bedfellows: Donald Trump, the city's most flamboyant builder, and the Municipal Art Society, the landmarks watchdog group that proved so active in the Rice Mansion dispute. Trump informed First Boston, according to press reports, that he wanted to buy the site outright or be let in as a 50-percent partner. When First Boston declined, Trump reportedly shot back, "I can't imagine a tower going up on that site that would block the view of the people who bought apartments from me [in the Trump Tower, diagonally across the street]—unless, of course, my name were on the project." When refused again, Trump responded, "I hope you don't have any problem with the Municipal Art Society, and I'm telling you I can be of great benefit to seeing that the project goes ahead."[3]

True to his word, Trump became a born-again preservationist, joining the Society's fifteen-member Committee for the Future of Fifth Avenue and declaring his opposition to the proposed office building which, he opined, would deprive Fifth Avenue of "light and air." Four months later, the landmarks commission—may I say it—"trumped" First Boston's proposed tower by designating the Rizzoli and Coty buildings as landmarks. Predictably, Trump, the commission, and the Municipal Art Society saw the outcome as a vindication of the law and of the public interest. First Boston felt otherwise. "If [the commission] think[s] there are 200 buildings that are worthy of landmarking, then landmark them," it complained. "You don't lie in ambush and wait for unsuspecting people to file building plans."[4] The *New York Times* concurred: "No building should hang in controversy for 18 years." Nor, it added, do "zoning considerations belong in the landmarking process."[5] Designation of the Rizzoli and Coty buildings, the *Times* worried, functioned much as designation of the Rice Mansion did in the earlier yeshiva–West Side dispute—a kind of eleventh-hour zoning invoked to preclude unwanted new development, not to celebrate the supposed aesthetic merits of the old.

To the legal eye, the charge that the commission exceeded its landmarks jurisdiction by exercising zoning powers calls into play the separation of powers and void for vagueness doctrines. The issue

posed by the first is whether the landmarks commission, as agent, had been adequately instructed by its principal, the legislature, which defined the commission's mandate in the first place. Purportedly a landmarking agency, the commission acted as a zoning agency, according to First Boston and the *Times*. Did the commission veer out of orbit because the legislature failed to cabin its behavior by adequate standards? If so, lawyers would term its action a violation of the separation of powers doctrine.

The void for vagueness objection appears in First Boston's inability to divine when and in what fashion the landmarks law would be implemented. Conceding that risks attend any business investment, First Boston's lawyers would claim, landmarking by ambush should not have been among them given the commission's eighteen-year record of inaction. A vague commission mandate also invited Trump's alleged effort to secure a piece of the action by threatening to link up with the Municipal Art Society to defeat the office tower project. Indecipherable standards, we have already seen, can warp the administration of public programs by exposing them to manipulation by the private sector no less than by administrators themselves.

"Restraints on Expression"; or "Are We Using the Law Simply to Allow Some to Impose Their Taste on Others?"

Back in the mid-1960s, a retired college professor's protest against high real estate taxes created quite a stir among his neighbors in the upper-class suburb of Rye, New York. Rather than berate local officials or distribute angrily worded pamphlets, he strung a front yard clothesline with tattered rags, brassieres, and other items that jolted the townsfolk. Rye front yards are for azaleas, sculptured fountains, and manicured lawns. They are not fit locations for the discarded unmentionables of the good professor's wife, even if placed there in service of his protest.

More recently, a sculptress friend of mine began to place her work on her front lawn in Scarsdale, New York. Uninhibited in talent and expression, she had moved from work with stone and bronze to what she described as her "tree stump period." The stumps, obtained from swamps and bogs, were sinuous, poetic objects. What drove the neighbors loopy, I guess, was her passion for painting these ten-foot-high constructions in the gaudiest of Day-Glo hues. Carol just doesn't worry about things like associational dissonance. On the contrary, she lives it.

Then there's Stephen Kenney, the environmentalist in the Buffalo (N.Y.) suburb who attracted national media attention in 1984 when he grew a "small meadow" in his front yard. Outraged, his neighbors claimed that the "meadow" was in fact an unkempt lawn sprouting three-foot-tall weeds in which rodents and insects nested. The village

attorney spoke more directly to the point: "Appearances are a major part of this case . . . [because] the property does not fit in with the residential community." Unfazed, Kenney invoked the spirit of Thoreau and retorted that what might look like weeds to his neighbors was actually "a natural yard, growing the way God intended."[6]

Suppose incensed neighbors succeeded in convincing town officials that "there oughta be a law" to ban these practices (as they actually did in the first and third cases). The process value placed in issue by such bans, of course, is freedom of expression. In appealing a judge's decree that Kenney must cut his "meadow," for example, Paula Rosner, an American Civil Liberties Union branch director, reasoned that "by growing his yard the way he has, he is expressing his philosophical attitude on life."[7] The Rye college professor went to jail insisting that his clothesline was but a latter-day version of the Boston Tea Party, a celebrated exercise in nonverbal political protest. I'm not sure how Carol would have defined the symbolic content of her front yard display if they'd tried to cart her away.

The "Takings Issue"; or "Why Should I Have to Foot the Bill for an Icon That You Want?"

Suppose after months of looking you finally find a house that fits your needs and your pocketbook. The lot is a bit unusual because in the backyard there's an abandoned 1922 gas station done in a neo–Italian Renaissance style. Fortunately, you can replace the derelict structure with a garden at an affordable price. You buy the property and prepare to demolish the gas station. Just then, the city's building inspector comes along. Not only does he deny you permission to proceed, but he orders you to restore the gas station, an undertaking that will cost you $100,000 and have bureaucrats monitoring every nail you drive.

Something similar happened to Sandra and Robert Wagenfeld, who bought their house and gas station in Manhattan's Greenwich Village Historic District. Mrs. Wagenfeld thought the whole thing "nutty," but the city's landmarks officials did not. Said one: "This little classical revival gas station is a marker of the city's history, not hidden away somewhere in a library, but sitting there on the street. It's a way people can touch base with how the Village came to be—not just the village of writers and artists and radicals, but people like you and me, some of whom had cars and needed a gas station."[8]

Let us grant—in my case, with no little discomfort—that the official plausibly described what landmarks commissions should be worrying about. The question remains whether there are no limits on the government's power to impose costs or coerce behavior once some linkage or other is demonstrated between private property and the past. May public officials act with the freedom of museum cu-

rators, even though the government, unlike the museum, has not paid for and does not own the objects in "its" collection?

Put questions such as these to lawyers and they will immediately point you to the language of the Constitution's Fifth Amendment: "nor shall private property be taken for public use, without just compensation." They will also initiate you into the mysteries of the "police" and "eminent domain" powers, pointing out that the government need not compensate you for your losses under the first but must do so under the second. Whether the government must pay (i.e., must utilize the eminent domain, rather than the police, power in effectuating an aesthetics regime) is termed the "takings issue" by lawyers. Translated into lay language, the question it asks is who should bear the costs of aesthetics programs: icon owners, such as the Wagenfelds, or the community at large, which insists upon preservation of the icon the Wagenfelds didn't want.

The takings issue confronts aesthetics programs because they can be more intrusive of private rights than more conventional forms of land use regulation. The Wagenfeld situation is by no means untypical. Like the Wagenfelds, the yeshiva lost the right to determine what would remain and what could be built on its West Side site. The Wagenfelds' loss meant that they had to keep a gas station they didn't want and could not plant the garden they did. The yeshiva ended up as the Rice Mansion's disgruntled curator while forfeiting the opportunity to upgrade its financially troubled religious and educational program.

The Wagenfelds were also required to lay out $100,000 to rescue the gas station from dereliction. Again, however, such affirmative obligations are not unusual. Aesthetics legislation often tells you what you *must* do with your property, unlike traditional zoning, which typically restricts itself to telling you what you may *not* do. The owner of New York City's Grand Central Terminal, for example, must maintain the Jules Coutan statuary atop that landmark's south facade, just as the holders of areas deemed nature preserves by the state are increasingly forced to maintain wildlife habitats on them.

Process and End-State Values: Pathways to Accommodation

By now it should be evident that the questions posed above admit to no easy answers, if, indeed, to any final answers at all. Neither do conflicts perturbing troubled marriages, yet many of these marriages have been made to work. So too can the law/aesthetics merger, I am confident, provided that the partners are willing to readjust their expectations in light of what experience has taught them about themselves and each other.

The Purpose Question

Aesthetics initiatives shape our dealings with our property, with each other, and with the state. They bar us from doing what we want while forcing us to do what we would prefer to avoid. They provide us with tax windfalls and they delay our projects interminably. They induce private, productive investment in long-derelict neighborhoods, seaports, and marketplaces, and they add untold sums to the developer's bill for unproductive administrative and legal costs. They confirm a sense of community, stability and identity for some but shatter it for others. They encourage sensitive accommodation of the familiar and the novel while coercing design-by-formula. They attract the able and public-spirited into some public agencies and turf-building bureaucrats into others. They initiate thoughtful public policies and they spout jingoistic nonsense. They

"I feel I should warn you. They've taken down most of Boston and they're putting up something else."

Pathos and Place

The "sense of self in a place" noted by Donald Appleyard underlies the emotional loss experienced when the place is changed or destroyed. A continuum, defined by the rapidity and violence of the loss and the extent to which the place hosts values fundamental to the self, registers the magnitude of the loss. Destruction of icons by warfare, earthquake, or flood may be more traumatic than the gradual inroads made by new development, but the distress occasioned by both derives from the same psychological needs.

package power, sometimes used to enhance community welfare and sometimes to undermine it.

Little can be said about legal aesthetics in one breath that cannot plausibly be denied in the next. Hence, the necessity of thinking as clearly about legal aesthetics' purpose as this elusive topic allows. The government should not set in motion programs capable of generating such far-flung and contradictory results absent the focused vision of the program's ends and means as envisaged by the substantive due process doctrine. For legal aesthetics, unfortunately, that vision remains blurred to this day. For example, many judges embarrass us and themselves in their clumsy attempts to found legal aesthetics' public purpose in beauty. Those who insist that the government may zone "solely for aesthetics" don't even try. Their formula calls to mind the nineteenth-century Romantics' rallying cry, "art for art's sake," as well as Keats's " 'Beauty is truth, truth beauty'—that is all / Ye know on earth, and all ye need to know."[9]

Aside from confusing metaphysics with law, these judges beg the question. Even assuming—as I do not—that beauty can be defined for legal purposes, judges are still obligated by the substantive due process doctrine to identify the governmental purpose advanced by measures enacted in beauty's name. Those who attempt this step often sink even further into the mire as, from time to time, the moral theory of art creeps into their discourse. A favorite of Plato and John Ruskin, the claim is that good art makes good citizens, and vice versa. Unfortunately, the theory was praised by Hitler as well, who banished the Bauhaus School from Germany lest it corrupt the Third Reich. The asserted linkage between art and civic virtue is simply too problematic, moreover, to serve as a persuasive justification for aesthetics regulation. Indeed, Lewis Mumford stands Plato and Ruskin on their heads with his observation that "the more shaky the institution, the more solid the monument: repeatedly civilization has exemplified [the] dictum that the perfection of the architectural form does not come till the institution sheltered by it is on the point of passing away."[10]

Other judges take refuge in the assertion that beauty's preservation increases property values. Sometimes the facts support the assertion, as in the case of gentrifying areas designated as historic districts. But the facts often cut the other way as well. My own studies in Chicago document that, depending upon the building in question, landmark designation can severely diminish a structure's value and its resulting tax yield to the city.[11] Likewise, aesthetics measures often freeze development at levels that fall well short of an area's optimum economic use, as Walter Firey pinpointed in his review of land values and land use patterns in Boston's Beacon Hill and Back Bay areas.[12] No less unsettling is the failure of these judges to take their argument seriously. Close reading of their opinions reveals that their efforts to verify the supposed beauty/property value relationship are perfunc-

tory at best. Many opinions, moreover, sustain such measures in the teeth of the concession that the measures may reduce the regulated property's value or diminish the community's economic welfare.

Fortunately, encouraging signs can be detected in more recent judicial opinions intimating a shift from a beauty- to a stability-based rationale for legal aesthetics. Illustrative is the statement of a District of Columbia court contained in its ruling on a controversy concerning the proposed demolition of Washington's Willard Hotel, a National Register of Historic Places entrant: "The retention of fine architecture, especially in the capitol city of a relatively young country such as ours, lends a certain stability and cultural continuity, which can only contribute over the years to national substance."[13] To like effect is the comment of a Michigan judge in a 1972 opinion sustaining a municipal sign ordinance: "The modern trend is to recognize that a community's aesthetic well-being can contribute to urban man's psychological and emotional stability. . . . We should begin to realize . . . that a visually satisfying city can stimulate an identity and pride which is the foundation for social responsibility and citizenship."[14]

Similar movement is evident on the legislative and administrative fronts, perhaps most clearly in the field of historic preservation. While various statutory or administrative texts could be cited, none better reflects this movement than the following excerpt from a 1981 United States Department of the Interior policy directive: "The historic buildings in a community are tangible links with the nation's past that help provide a sense of identity and stability that is often missing in this era of constant change. . . . Preservation is an anchor that keeps communities together and re-establishes pride and economic vitality."[15]

The reformulation of legal aesthetics' goals suggested in these excerpts and advocated throughout this volume affords a cogent response to the substantive due process objection. No less important, it provides the legal system with an equally cogent point of departure for preventing unwitting encroachments upon the other process values discussed in this chapter.

The Standards Question

Coherent standards avoid entanglement with separation of powers and void for vagueness objections. Lawmakers who know what they want and instruct their administrators accordingly need not worry that a court somewhere down the line will conclude that they have invited administrators to usurp the legislative role. Nor will these lawmakers be vulnerable to the charge that property owners are unable to determine what the aesthetics regime in question requires of them, especially if administrators do their work as conscientiously as the lawmakers have done theirs.

Beauty and Standards Setting

Coherent standards are unachievable in a beauty-based legal aesthetics because beauty cannot be confined by standards. To this extent, at least, the turn-of-the-century judges had it right. The legal system would indeed totter on a seesaw if legal aesthetics were a matter of choosing between jazz and Beethoven, posters and Rembrandt, or limericks and Keats. But equally unsustainable is a vision of beauty as something objective, existing "out there," and renderable in a series of rules readily transformed into legal maxims. The vision dissolves before the contrary evidence detailed in the previous chapter: absence of a consensus on beauty's canons and nonverifiability of their objective character; time as a relativizer of taste; vagaries of cultural diversity and of perceptual response; and the exuberance of artistic creativity, which refuses to be immobilized by the rules or traditions of received styles.

Then, too, there are the other dead ends spawned by the beauty fiction. Law cannot create beauty anew. More modest and derivative, its charge is to safeguard icons, which may or may not be "beautiful" in some formalistic sense, against marauding aliens, which may or may not be "ugly" in that same sense. Nor need aesthetics standards be as refined as those of the museum. Worries about Beethoven, Rembrandt, and Keats seem oddly out of place when the aliens opposed by these standards line up as billboards, porno parlors and X-rated cinemas, junkyards, high-rise towers, sodium vapor lamps, and front-yard clotheslines and "meadows."

Stability and Standards Setting

Stability reasoning points us in another direction that is not without its own dangers. But they can be held at tolerable levels, I am persuaded, if standards setting is approached with greater conceptual rigor and informed teamwork between the legal and social systems. Standards are a product of political and social forces no less than of "pure" legal considerations. Given fundamental differences between icons and aliens, moreover, standards governing icon selection should be expected to differ from those controlling icon protection (or, what is the same thing, alien selection). Finally—and here's the bad news—it must be recognized up front that there are some icons for which administrable standards simply cannot be devised.

Let us explore how standards are fixed by distinguishing between two types of draftsmen, referred to here as "purists" and "Metternichians." Both recognize that a standard's function is to channel the behavior of the public, administrators, and judges along pathways that promise to resolve the problem at hand. If that problem is the loss of icons, for example, a properly constructed statute should contain standards that communicate this purpose, define the criteria that govern the selection of icons and aliens, and identify the procedures by which the one will be protected from the other.

Purists approach the standards quest as though it were predominantly a challenge of intellect and linguistic refinement. A standard is "pure," that is, if it proceeds from a solid understanding of the problem and directs the behavior of the pertinent actors by language so crafted that all know what is expected of them. Metternichians, by contrast, are devotees of the maxim attributed to the tough-minded chancellor: "A law is like a sausage; it is better not to ask how it was made." But ask they do in order to round out the purist's incomplete vision and, in doing so, to determine realistically what can and cannot be expected of standards in the legal aesthetics sphere.

Standards emerge, their inquiry discloses, as the product of a trade-off among a variety of considerations omitted by the purists' idealized vision. To begin with, there are the limitations of language itself. This drawback, which is common to all legal fields, is a double headache for legal aesthetics. How can design values be translated into language of *any* kind when, as Louis Sullivan reminded us, "art will not live in a cage of words" because "there is a vast domain lying just beyond the reach of words" accessible only "in terms of pictures, of states of feeling, of rhythm"?[16] Compounding the problem is the necessity of using legalese as the medium of communication. The law's rigid syntax is decidedly ill fitted to pinpoint design values.

Metternichians factor in the intensity of the public's devotion to the legislative goal as well. They recognize that the legal system shares the disposition we all feel to tolerate greater imprecision when we prize a particular outcome than when we do not, and vice versa. What is precise or imprecise is as much a matter of social priorities as it is of language. Because aesthetics has achieved favored ranking among these priorities, the risk is patent that standards that would occasion embarrassment in less-favored fields will be tolerated in aesthetics regimes.

Attention is also directed to the locale and resource in question. The United States is many design communities, not one. Some are sophisticated, or at least stridently opinionated, in these matters; others couldn't care less. The advent of a downtown skyscraper, which typically provokes violent debate in San Francisco, may be greeted with a yawn in other cities. That San Francisco's design regulations are as elaborate as any in the nation comes as no surprise. What is being regulated makes a difference as well. Even Procrustes would join Metternichians in anticipating variations in detail and texture among measures addressing resources as diverse as San Francisco's skyline, Chicago's Monadnock Building, New Orleans's Vieux Carré, and unfenced junkyards in Anywhere, U.S.A.

Whether or not there are safeguards external to the standard itself also deserves notice. Many preservation laws, for example, reserve places on the landmarks commission for architects and historians

and envisage an expert staff to provide needed research and documentation for commission decisions. Included as well may be such procedural constraints as public hearing and notice requirements and appeals from administrative decisions back to the lawmakers themselves.

The mission of the regulating agency cannot be ignored. Straightforward missions require less in the way of standards; complex missions, more. Illustrative is the contrast between landmark preservation as initially conceived and as now practiced in many cities today. Earlier on, buildings and neighborhoods were selected on the basis of documentable historical or architectural characteristics. Hard cases requiring tough judgment calls arose even under this restrained format. As a general matter, however, few would question such selections as, let us say, the Vieux Carré, Mount Vernon, or the Gettysburg National Cemetery. Preservation functioned tolerably well, even with standards so vacuous that, taken literally, just about anything seemed to qualify for designation. What neighborhood, for example, would *not* merit designation under New York City's definition of a historic district as any area having a "special character or special historical or aesthetic interest or value . . ."?

As time has passed, preservation's mission has grown like Topsy. Designation is no longer confined to historically significant places or to buildings and neighborhoods that exemplify established architectural styles. More important, preservation in many cities has become intertwined with zoning, which, relatively speaking, is confined by detailed standards that have been further refined by extensive judicial interpretation. With few exceptions, however, lawmakers have neither endorsed preservation's expanded mission nor provided the more demanding standards that it obviously necessitates. So we have the additional danger that, in acting as de facto zoning agencies, landmarks commissions may enjoy the extensive powers of the former but operate free of standards confining these powers.

Metternichians would conclude this list with what is perhaps its most significant entry—the character of the political consensus be-

Icons and Aliens: Self-Declaring or Otherwise

Certifying that an environmental feature merits legal status as an icon or an alien is often the most difficult issue in aesthetics controversies. Some icons, such as New Orleans's Vieux Carré, are virtually self-declaring. Others are considerably less so, which is why education, media, and public relations efforts are so vital to their identification and protection. Aliens too seem to fall along a spectrum of greater or lesser certifiability. Some seem to have gained near-incontestable status as such. Billboards and junkyards count among this group. Most, however, come to be recognizable only after the fact and in conjunction with the particular characteristics of the icon with which they are paired.

hind the program for which standards must be set. A strong consensus favors lucid standards, which detail the program's likely consequences for the various groups affected by it. Lawmakers and administrators needn't fear clarity in such instances because they know that the aesthetics regime will be welcomed by these groups. However, a weak consensus virtually guarantees vague standards because lawmakers and administrators have every incentive to submerge potential conflicts rather than expose them by spelling out what the program is intended to do. That vague standards will pervade aesthetics measures is therefore entirely, if regrettably, predictable. As vehicles for allocating power to control environmental change, these measures often divide the world into adversaries — be they yeshivas and West Siders, Korean deli operators and Park Avenue residents, or Lower East Side leatherworkers and East Village Yuppies.

Viewed from this angle, the question of standards treats no less with political conflict than it does with the draftsman's vocabulary or the designer's expertise. When lawmakers paper over conflict with meaningless verbiage, they pass the buck to administrators and judges, who are then forced to use technical or judicial tools to cope with political questions.

If that's how laws get made, you may ask, why should sound standards be any more achievable from a stability perspective than from a beauty perspective? In many cases they won't; hence my earlier caution that some resources that are icons in the society should not be such in the law. But in other cases they will. The trick for lawyers and laity alike is to appreciate that, with all its supposed majesty, the law is not a miracle worker.

The icon/alien metaphor invites inquiry into what it takes to mesh lay expectations with the law's capabilities. As developed below, the inquiry differentiates icon selection from icon protection. Standards governing icon selection should address two considerations: validity of the claim that an environmental feature has actually become an icon in the community mind; and the likelihood that it is amenable to regulation by the land use tools employed in aesthetics regimes. Standards applicable to icon protection should take into account the distinctive features of the icon in question and should be drawn to prevent or minimize associational dissonance between that icon and prospective aliens.

Selecting Icons

Icons are creatures of society. Social values are the catalyst transforming neighborhoods, rivers, or even the first McDonald's hamburger stand into icons. Their serendipity, however, is both their glory and their curse. Who can foresee the content or shelf life of these values? Who can prophesy the building or place around which

they will coalesce? Certainly not the law, which is reactive, not prescient.

As gatekeepers of the legal portals, lawmakers must begin by asking whether or not shared community sentiment supports the claim that this or that resource is an icon. It is not simply that icons are icons only because they are so regarded by the community. In a democratic nation, it is *community* support that legitimates the decision to confer legal status upon icons in the first place. Unlike the despots of the past, American lawmakers may not shape aesthetics policy by fiat, nor may they do so by reading the canons of Vitruvius into the Constitution.

How can lawmakers know if community support is sufficiently broad-based? Sometimes it's easy, because the support declares itself. The Vieux Carré became a historic district through a Louisiana-wide constitutional referendum. So too did a statewide billboard ban in Massachusetts. As the Massachusetts Supreme Court stressed in sustaining the ban, the latter "is not a mere matter of banishing that which in appearance may be disagreeable to some. It is protection against intrusion by foisting the words and emblems of billboards upon the mass of the public against their desire."[17] Support may also declare itself by the persistent call for certain categories of aesthetics regimes, such as those regulating junkyards or billboards. These regimes evidence "concepts of congruity held so widely that they are inseparable from the enjoyment and hence the value of property,"[18] as one perceptive judge put it.

Oftentimes the determination is not so easily made. In fact, it may be legal aesthetics' toughest single challenge, as it is for democratic decision making overall. Lawmakers are not simply wax tablets on which the will of the people is written. Aesthetics policy is often too complex to be handled in a New England town-meeting format. Popular support for sound aesthetics policies may fail to emerge absent legislative leadership. And preferences initially espoused by such groups within a community as its design professionals, critics, and allied civic groups often win broad popular acceptance only after education and public relations efforts championed by such groups.

Lawmakers are not bereft of options in such instances. They can get a line on community attitudes through hearings and other public proceedings, just as they do when legislating in other fields. They can also approach the question from the other end by seeking to gauge the extent of community opposition to initiatives they believe meritorious. The absence of a consensus against does not prove a consensus for, of course, but sometimes it's the best that can be gotten in these matters.

Lawmakers must also ask whether the icon in question is one for which administrable standards can be devised. Aesthetics regimes

cannot protect ideas or feelings as such, only the physical features of the icon that signify these ideas or trigger these feelings. But associations that cause us to think of some resources as icons may be resident elsewhere than in their physical features or, even if there, unrenderable in terms of coherent standards. Although these resources too may qualify as genuine icons in the community psyche, treating them as such within the law is inadvisable.

A case in point is New York City's decision to designate its Upper East Side as a historic district. If ever an area qualified as an icon, the Upper East Side is it. Even its popular name, the Silk Stocking District, evinces the diffuse images of wealth and social prestige with

"It says, 'So rich in literary associations is this quarter of town, so vividly evocative of the characters and events with which it is inevitably linked in our minds, that we are half prepared to see them spring to life before us as we walk its streets.'"

Place as a State of Mind

"A city," Grady Clay reminds us, "is not as we perceive it by vision alone, but by insight, memory, movement, emotion and language. A city is also what we call it and becomes as we describe it." Far more than a physical configuration, a city is a creation of imagination, a collectivity of associations assembled over time in response to human needs and aspirations. Some of these associations can be kept intact by preserving their physical hosts. But others cannot because they exist in the mind alone, not in observable physical characteristics or activities. The latter, in fact, may be quite at odds with the mental image.

Icons and Aliens

which it is associated. The Upper East Side is New York City's Nob Hill and Gold Coast combined. In short, it is a state of mind, much like the city's Garment District, which is devoid of architectural reference points, or Little Italy, which now features more Asian-Americans than Italian-Americans.

Why is this problematic, since all icons exist in the mind? Because those capable of generating administrable standards are also incorporated in a physical host, which contains distinctive features that afford a coherent framework from which these standards can be derived. The Upper East Side is not such an icon. This 60-block, 1,000-building area undoubtedly includes a number of individual buildings and blocks for which workable standards could be drawn. But the claim, essential to historic district status, that the Upper East Side Historic District as a whole is architecturally coherent is disingenuous. By the city's own count the district contains upward of sixty-three different architectural styles, ranging from numerous Beaux Arts variants to "styles" the city labels "None" or "Modern."

Speaking to this problem, restoration architect Giorgio Cavaglieri observed that "the 'character' of [the Upper East Side Historic District] is not due to the preponderance of carefully designed facades with constant elements of style and compatible selections of materials. . . . [Rather it] is created by the small size of the properties and the low level of the roofs [and] . . . [the] strong social force . . . [of] the recollection of the elegance of these addresses which reminds one of the famous names of New York Society."[19] But if the area's features cannot be delineated coherently, how are proposals for new development to be evaluated? What yardstick should the administrators employ, for example, if presented with a proposed facade change for a building cataloged as "Style: None," flanked by neighbors to the left and right deemed "Style: Modern" and "Style: Victorian," and looking across the street at a bevy of "Style: Beaux Arts"?

Anomalies so glaring usually signal that the problem giving rise to the flawed aesthetics regime is one that falls beyond the regime's legal purview. Rather than condemn the deviation outright, however, I think it is more helpful to ask why in such cases the icon's constituency seeks and administrators acquiesce to the regime rather than pursuing an alternative that avoids these obvious legal and technical objections. The answer is readily forthcoming in the Upper East Side case: influential East Side groups sought to impose a preservation solution on what is, at base, a zoning problem and the landmarks commission concurred. Any doubts that the historic district designation was a thinly veiled zoning exercise were quickly dispelled by Paul Goldberger's summary of the objections posed to the first of the development proposals to come before the landmarks commission after the District's creation—a twenty-story apartment building on East Seventy-first Street: "Preservationists are arguing

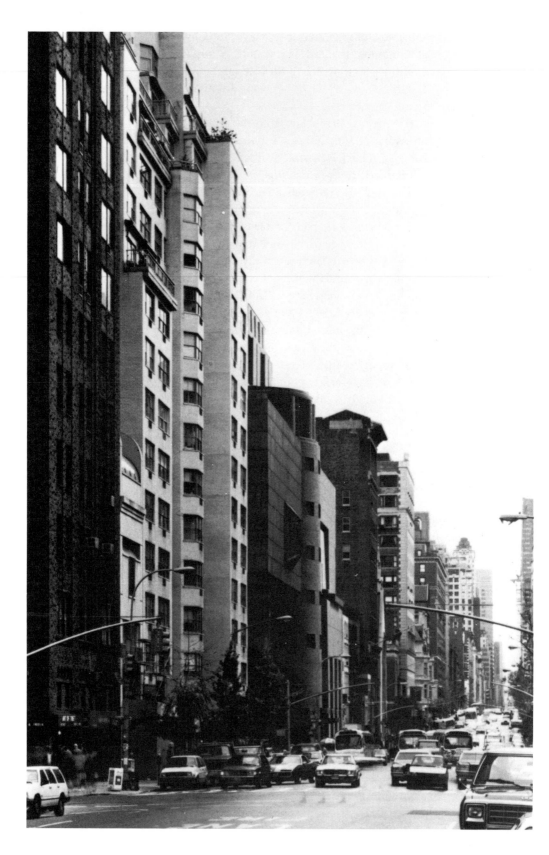

The Upper East Side Historic District: Two Views

Coherence of form, materials, style, and period is the predicate for an area's designation as a historic district. East Seventy-fourth Street between Madison and Fifth avenues clearly evidences coherence, warranting its inclusion within New York City's Upper East Side Historic District. But similar status for Madison Avenue (opposite page: south along Madison Avenue toward and including the Whitney Museum) is problematic at best. Historic designation loses all meaning when locations featuring buildings and streetscapes so lacking in coherence receive that status.

that the designation . . . was intended to prevent tall buildings, not to permit them . . . and that the proposed project would destroy the gentle nature of the . . . block on which it would be located, now one of the few full city blocks on the Upper East Side to contain no tall buildings, and that it represents another attempt to shoehorn development into tight Manhattan sites."[20]

The summary is instructive on two counts. Its reference to still "another attempt" pinpoints the East Siders' fears that the city's zoning authorities would approve buildings as large within the district as they had earlier allowed on sites to the district's immediate south. East Side watchdog groups distrusted these authorities and believed, correctly as it turned out, that they would receive a more sympathetic hearing from the city's landmarks commission. The summary also confirms Cavaglieri's admonition that the dispute centered on zoning, not historic preservation. Pertinent New York legislation allocates questions of scale, size, and volume principally to the city's zoning authorities, specifically withdrawing them from the city's landmarks authorities unless they are directly linked to and threaten the achievement of bona fide preservation goals.

Why the landmarks commission concurred in the designation is unclear, although a proper subject of speculation. Certainly, the legislative definition of a "historic district" under which the commission functions is so sweeping that virtually any neighborhood, including the Upper East Side, can be fit within it. Operative as well may have been the commission's desire to enlarge its influence and budget in relation to the city's other land use control agencies. The controversy also afforded the commission an obvious opportunity to expand its influence within the community by linking up with such powerful citizens groups as the Municipal Art Society, which spearheaded the drive for the district's designation.

Whatever the commission's motivation, no controversy better illustrates how legal aesthetics' end-state and process values can operate at cross purposes. Let us assume, as probably was true, that the downzoning sought by the East Siders could be obtained only with great difficulty or, perhaps, not at all if it were pursued through the channels designated by law. Let us sympathize as well with the East Siders' fears that their neighborhood might soon become the site for the "tall buildings" they believed the city's planning commission favored. Under these circumstances, it is entirely understandable that they would be disposed to sacrifice the law's process values if doing so enabled them to avoid unwanted change.

Before we approve this choice, however, we must recognize that it converted the controversy into a naked power struggle in which the law's process values were overwhelmed by end-state values. Such result-oriented outcomes suffer the grave deficiencies detailed in my earlier critique of Robert Nelson's view that legal aesthetics should serve as a "subterfuge" for the privatization of public power. Such inevitably Pyrrhic victories, when aggregated over time, impose intolerable strains on the legal system and undermine legal aesthetics' credibility, its most precious asset.

Warding Off Aliens

Lawmakers stand on firmer ground as they shift their focus from selecting icons to zapping aliens. The reason: once selected, the icon itself becomes the template for alien-defining standards. Alien selection thus may be less problematic than commonly supposed, despite the concededly subjective character of the process by which associations come to be ascribed to icons. Icons are objects as well as the complex of associations ascribed to them, and as objects they often can be profiled in what, quite literally, are "objective" terms. So too can the specific physical features that undergird these associations.

To illustrate: San Franciscans are deeply attached to their city's image as one of hills descending gracefully to the bay. This attachment, of course, is entirely subjective. But standards preventing aliens from marring this image can be stated in topographical, engineering,

and other objective terms. Likewise, Board No. 7's castigation of the yeshiva's high rise as an "East Side building" oozes subjectivity. But controls precluding tower-plaza buildings from clashing with the West Side's scale can also be based on standards stated in objective fashion.

If this phase of the task is within the law's grasp, then, why the various instances in which it has been been poorly managed? One reason is that lawmakers often mistakenly assume that they have done their job by designing aesthetics regimes around the simple directive that aliens must be "compatible," "harmonious," or "congruous" with icons. These buzzwords cannot possibly guide anyone's behavior unless lawmakers or their administrative delegates go on to provide a profile detailing why the icon merits that status and, therefore, which characteristics of aliens qualify them as misfits.

Statutes or regulations that leave these matters up in the air are often a product of incomplete homework. It's hard work detailing what drives aesthetics regimes and constructing alien early-warning systems. Imprecision may also serve to paper over constituent conflicts or to expand administrative discretion. Or the associations that transform the resource into an icon may lack physical equivalents amenable to control by workable standards, as the Upper East Side case illustrates.

Judges, too, come in for their share of the blame. Properly, they have distanced themselves from their pre-Roosevelt brethren by their willingness to approve broader delegations of legislative power to administrators. The explosive growth in the government's size and complexity over the last half-century prevents legislators from managing public business by themselves. In consequence, actions that past courts would have deemed policy-making, and hence reserved to lawmakers, are now routinely viewed as policy implementation and therefore proper matters for the administrative grist mill.

Such general tendencies have been amplified in the courts' review of aesthetics measures and their toleration of vague standards, for reasons both good and bad. Correctly, they recognize that vague statutory language can often be clarified by administrators, who possess the time and design expertise to provide the detail that legislators cannot. Wrongly, they too readily assume that legislative guidance will always be adequate to govern administrative behavior and that, when it is, administrators will do the hard work of profiling icons and providing fair notice of what will or will not fit with these icons. If earlier courts can be accused of undue skepticism on the standards issue, modern courts fall prey to the charge of inattention to its genuine difficulties.

What is needed, then, is a course that splits the difference between these two postures. Clearly, the court's role in the standards-setting process is a reactive one. Their job is not to prescribe the community's aesthetics values or to second-guess the legislator's evaluation of the

depth of the community's attachment to this or that icon. Rather, the courts should function as editors, reviewing the scripts jointly authored by the legislators and administrators to ensure that they comport with the more fundamental constitutional values it is their job to police. The courts do not step out of their role by insisting that a challenged aesthetics regime specify with reasonable clarity its purposes, the salient characteristics of its icon, and the criteria that will be employed to ward off aliens. But in failing to do so, as this volume attests, they confuse property owners, accord undue deference to administrators, and deprive themselves of any reliable means for evaluating the programs before them.

There is nothing novel or daring in these suggestions. On the contrary, judges apply them routinely in reviewing other laws that are less intrusive of constitutional values than errant aesthetics measures. Why the difference? Misconceiving the problem, judges, like the rest of us, do not want to be counted among beauty's enemies.

The Censorship Question

A vision of the environment as a stage on which aliens slink about menacing icons is a vision of the environment as a network of meanings. Associational dissonance is a product of jarred meanings, of the incongruity between those we associate with an icon and those with its paired alien. Where there's meaning, there are usually a host of First Amendment issues lurking nearby because the line between meaning and First Amendment "speech" is often imperceptible. And so it should be. What else is expression but the communication of meaning, and which forms of expression communicate more effectively than those reviewed in this volume?

The same conclusion is suggested in the purposes served by the First Amendment: strengthening democracy through a free marketplace of ideas; permitting a variety of viewpoints on subjects whose truth or falsity knows no objective measure; and hastening personal fulfillment by encouraging robust, creative expression.

These values prosper when behavior controlled by aesthetics regimes is given free reign. That tattered front-yard clothesline in Rye, New York, was first cousin to the Boston Tea Party as an antitax protest. And Hugh Hardy's effort to acknowledge the unique character of his Greenwich Village site bespoke a message both personal and political.

Were these activities viewed as expression, their prohibition would raise a clear First Amendment censorship issue. Government may not ban expression, the United States Supreme Court has repeatedly ruled, simply because individuals or even broad majorities within the community find it offensive. Perhaps the most eloquent statement of this principle appears in *Terminiello v. City of Chicago*, in which the Court invoked the First Amendment to reverse a breach of the

peace conviction of a speaker who berated his audience with ethnic and racial slurs.

> . . . a function of free speech under our system of government is to invite dispute. It may indeed serve its highest purpose when it induces a condition of unrest, creates dissatisfaction with conditions as they are, or even stirs people to anger. Speech is often provocative and challenging. It may strike at prejudices and preconceptions and have profound unsettling effects as it presses for acceptance of an idea. . . . a more restrictive view [of the First Amendment] . . . would lead to standardization of ideas either by legislatures, courts, or dominant political or community groups.[21]

Surprisingly, the Court has failed to examine the implications of its position in the aesthetics realm, choosing instead to treat icons and aliens as mute physical objects rather than message bearers creating effects no less "unsettling" than Terminiello's tirade. In consequence, the Court has largely overlooked that aesthetics regulation often does clash with the spirit, if not the letter, of the First Amendment. A clash alone, however, does not establish a First Amendment violation. The Court has also routinely ruled that such clashes are not fatal provided the government can demonstrate that the otherwise tainted measure advances a "compelling" or "sufficiently substantial governmental interest."[22]

The pursuit of beauty will not survive this test. But bona fide efforts to buttress community stability often will, or so I contend in the balance of this section. Because the following paragraphs explore various subtleties of First Amendment doctrine, a roadmap may assist the lay reader in following my reasoning. I begin with the question of whether icons and aliens ought to be regarded as First Amendment expression at all. Answer: icons, no; some aliens, yes. I then inquire whether aesthetics regulation can hinder the expression of these aliens' sponsors, the "speakers" in the piece. Answer: yes. In conclusion I ask whether such infringements are violations of the First Amendment. Answer: how we come out depends upon what the interest served by aesthetics regulation is conceived to be and whether the measure in question actually serves that interest.

Icons: Message Bearers That Are Not Speech

Little purpose would be served by viewing icons as First Amendment expression because doing so would untenably broaden the amendment's scope and misread the way legal aesthetics threatens free expression. If icons are speech, who is the speaker? Nature, which created the settings now revered as one class of icon? The cultural chemistry and countless, usually unknown, hands that produced our historic districts? The architects of a bygone day, who may well have intended to convey a different message than the one we currently ascribe to their work? We, as creators and custodians of this latter-day message?

What First Amendment interest would be safeguarded by treating icons as speech? The icons' authors have already exercised their right to speak, having done so through a physical medium. Are they now entitled to have their message preserved inviolate in space and time? No doubt there are powerful reasons for protecting icons, but safeguarding free expression is not among them. The unhappy truth is quite the opposite: First Amendment values are not put at risk by the menace that aliens pose for icons. On the contrary, these values are threatened by the government's effort to forestall that menace by censoring "offensive" aliens, some of which do merit constitutional status as speech.

Aliens: Message Bearers That Sometimes Are Speech

The status of aliens as speech is not complicated by the foregoing anomalies: the speaker will always be the proponent of the environmental change in question. The question should turn, instead, upon a test advanced in a Vietnam-era Supreme Court decision treating as "speech" a flag displayed upside down with a peace symbol affixed to it. "An intent to convey a particularized message was present," the Court observed in its review of this nonverbal expression, "and in the surrounding circumstances the likelihood was great that the message would be understood by those who viewed it."[23]

Pragmatic application of this standard will preclude many aliens from qualifying as speech. Take Mr. Choi and his vegetables. The last thing on his mind, I'm sure, was to send a message to his Park Avenue clientele threatening their neighborhood's elite status. Nor, I assume, do workmen park lettered vans in their driveways to ridicule the socioeconomic aspirations of their lower middle-class neighbors. But the standard's requirement that "the message [be] understood by [its viewers]" should not be construed to deny status as speech to such obvious forms of creative expression as Hugh Hardy's Greenwich Village townhouse.

I say "should not" because the Supreme Court has yet to rule that architecture is "speech." But this conclusion is unavoidable, I believe, when the alien is a child of the creative effort of an architect or other design professional. For many, architecture and other environmental features communicate ideas more effectively than does language, a point captured in Louis Sullivan's description of the architect as "a poet who uses not words but building materials as a medium of expression."[24] Others stress architecture's capacity to evoke emotion through sensuous form, not ideas. Susanne Langer views its province as expressing such "rhythmic functional patterns" as "venture and safety; emotion and calm; austerity and abandon; . . . [and] the sacramental and the capricious moods that make a social order. . . ."[25]

Emotion-laden messages, however, are no less entitled to First

Amendment protection than discursive ones. Even when communication is verbal, the Supreme Court has recognized, the emotive function of language may be "more important" than its discursive function in conveying the "overall message sought to be communicated."[26] Nude barroom dancing[27] and, from the Vietnam protest era, black armbands,[28] a flag sewn onto the seat of one's pants,[29] and a jacket inscribed with the words "Fuck the Draft"[30] have qualified as First Amendment speech on this basis. Why not architecture?

The First Amendment, as earlier noted, nurtures human self-fulfillment as well. Interaction between artist and audience surely affords as direct a route to this goal as does the nude go-go dancer's barroom performance or the college student's display of his scatological jacket in a county courthouse. The power of art to enrich our lives is comparable to that of religion, another of the First Amendment's charges. Wisely, the Founding Fathers frowned upon state dictation in these two areas, whose affirmations and dogmas bear profoundly upon personal development yet are opaque to verification or criticism by any means known to the law.

Aesthetics Controls as an Infringement and Sometime Violation of the First Amendment

In contrast to its many subtleties, First Amendment doctrine is blunt in its insistence that government may not inhibit expression solely on the basis of the expression's offensiveness. Are there any limits, then, to "offensive" speech? Yes, the Court advised in *Terminiello*: ". . . freedom of speech, though not absolute . . . is nevertheless protected against censorship or punishment, unless shown likely to produce a clear and present danger of serious substantive evil that rises far above public inconvenience, annoyance, or unrest. . . ."[31] A quarter-century later, the Court reformulated this standard for aesthetics measures, which, it announced, must be "narrowly drawn" and further "a sufficiently substantial governmental interest."[32]

Given these precedents, it is easy to see why the First Amendment is so difficult to square with a beauty-based legal aesthetics. "Why," a latter-day Louis Sullivan might understandably complain, "should my work be turned down or tinkered with by governmental censors while the work of poets, painters, and playwrights that is even more 'offensive' to the public escapes scot-free under the First Amendment?" The response that Sullivan's work is "ugly" flunks both the "narrowly drawn" and "governmental interest" prongs of the Court's standard.

A challenged measure that appeals to beauty in the abstract will be hopelessly vague, not "narrowly drawn." Aesthetics measures rarely do so, however. They usually look instead to the visual features of an existing style for their standards. The Rice Mansion, for example, was designated under an ordinance that defines a landmark

Beaux Arts, International, and Postmodern: The Pendulum (Partially) Returns

Inspired by the "City Beautiful" movement of the late-nineteenth-century, Neoclassical streetscapes were featured in the downtowns of American cities (above: Lower Broadway in New York City, including the Singer Building). International Style streetscapes and buildings followed toward mid-century (opposite page, top: Third Avenue and Fifty-fourth Street in Manhattan). During this same period, the International Style also prevailed in the design of individual buildings (opposite page, middle: the House of Seagram by Mies van der Rohe and Philip Johnson). Since then, Postmodern architecture, with its many gestures to its Neoclassical roots, has come into vogue (opposite page, bottom: the AT&T Corporate Headquarters by John Burgee Architects with Philip Johnson).

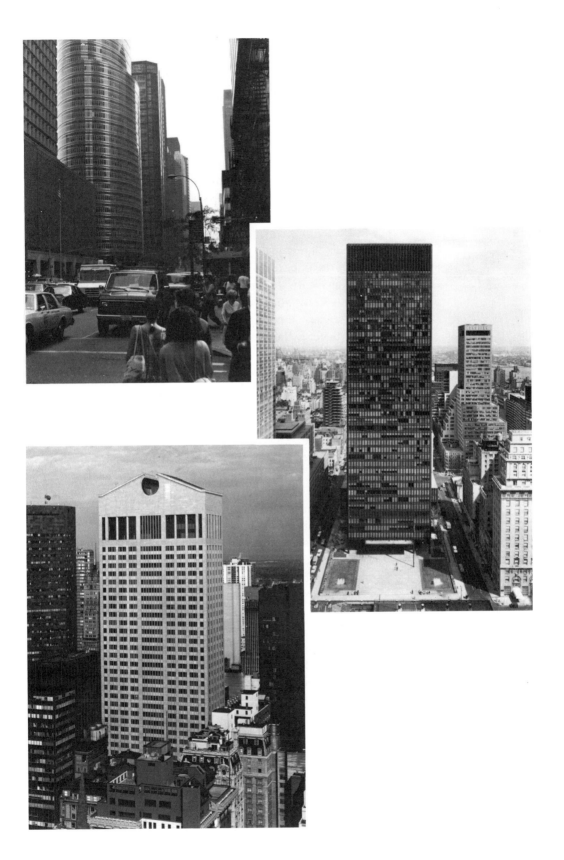

as a structure having "a special . . . aesthetic interest or value,"[33] a criterion that New York City's landmarks commission presumably concluded the mansion met by virtue of its Beaux Arts and Neo-Georgian features. Measures of this type may avoid the "narrowly drawn" objection since a period style's visual features can be profiled by design professionals. But the censorship problem is hardly solved, because the claim that Beaux Arts, Neo-Georgian, or any other style is "beautiful" is one that government may not make if its effect is to deny Sullivan's expression. Under the American constitutional system, government may not impose a design orthodoxy upon its citizens.

The "sufficiently substantial governmental interest" criterion also receives short shrift, even if we assume that aliens are offensive because they are unbeautiful. Offensiveness alone, *Terminiello* teaches us, can never justify censorship. Free expression serves its "highest purpose," the Court stressed, by creating "unrest," "dissatisfaction," and even "anger," the very effects so often attributable to aliens. Something beyond these effects is required, something the Court identified as a "substantive evil that rises far above public inconvenience, annoyance, or unrest."

Here, I think, is where the divergence between museum and courtroom aesthetics is most pronounced. "Unbeautiful" expression and "illegal" expression are two very different animals. Expression is unbeautiful because it deviates from whatever conception of beauty the critic may entertain. But expression can be declared illegal only if lawmakers determine that its social effects are so grave as to override the powerful First Amendment presumption against its suppression and if judges agree with that determination.

Substituting stability for beauty doesn't eliminate the tension between legal aesthetics and the First Amendment. Nothing can. But the substitution at least helps us to be clearheaded about the tough trade-offs forced by aesthetics regulation and advances a rationale for legal aesthetics that is more in keeping with the Supreme Court's two-pronged test. Why? Because measures faithful to the rationale are more likely to square with what the Court terms "government's paramount obligation of neutrality in its regulation of protected communication."[34] Government runs afoul of this obligation, of course, when it bans expression solely because it is hostile to the expression's message.

Can a measure that regulates expression on the basis of its content remain neutral in the Court's sense of that term? Yes, by addressing itself not to the expression as such but to the expression's social consequences, the regulation of which must independently qualify as a "sufficiently substantial governmental interest." Beauty-based measures flunk this test. If not premised solely on the expression's offensiveness ("ugliness"), they seek justification in an asserted but

fanciful linkage between the expression's lack of beauty and its socially damaging effects.

Stability-based measures need not be impaled on this First Amendment objection if, as argued elsewhere, aliens often destroy stable land use patterns by eroding the ties that bind people to places. Preservation of these patterns not only is a valid governmental concern but "the most essential function performed by local government,"[35] as one Supreme Court justice put it. Despite their restriction upon protected speech, measures that serve this function respect government's "paramount obligation of neutrality": the target of their hostility is the expression's harmful social effects, not the offensiveness of its content.

Two Supreme Court opinions signal that this reasoning will prove persuasive on the day that surely must come when the Court finally acknowledges that aliens are message bearers as well as physical objects. I refer to the Court's rulings sustaining a Detroit measure that required the dispersion of pornographic movie houses[36] and striking down a Mount Ephraim (N.J.) law that banned live nude dancing within its municipal boundaries.[37] Detroit feared that residential neighborhoods would be destabilized by the concentration of pornographic theaters nearby. Mount Ephraim reacted in pique to a live nude dancing act that had recently commenced in an "adult bookstore" located in its business district.

With a single exception (discussed presently), these disputes track this volume's format for aesthetics controversies. In the Detroit case, the challenged measure was designed to preserve the city's neighborhoods (icons) from invasion by a concentration of porno theaters (aliens), which neighborhood residents perceived as dissonant with their family-centered life-style. In the Mount Ephraim case, the measure sought to immunize the municipality's character as a rural, family-centered borough (icon) from contamination by live nude dancing performances in a porno bookstore (alien). Taken together, the Court's opinions in the two cases advise that the outcome of First Amendment–aesthetics controversies will be shaped by an evaluation of the community's claims that icon and alien actually are dissonant and that this dissonance truly threatens (poses a "clear and present danger" to) the stability of the community's land use patterns.

Mount Ephraim lost because, as one justice put it, the borough failed to establish that live nude dancing "introduced cacophony into a tranquil setting [rather than] merely a new refrain into a local replica of the Place Pigalle."[38] That is, Mount Ephraim failed to prove either that the live nude dancing–adult bookstore activities were aliens or, if they were, that their dissonance was so strident as to destabilize the icon, Mount Ephraim. The Court concluded that the ban was nothing more than censorship of behavior the community

leaders found offensive. By contrast, Detroit won because it per-
suaded the Court that the "cacophony" between porno theaters and
stable residential neighborhoods would be deafening and that the
neighborhoods' stability would likely fall victim to it.

The single difference between these disputes and this volume's
icon/alien format lies in the medium of expression at issue. Featured
in the Detroit and Mount Ephraim disputes were media that the
Court had previously agreed could qualify as First Amendment
expression: movies in one case, books and nude dancing in the other.
Conservatively interpreted, the Court's reasoning in the two disputes
cannot be extended to aliens because neither in these cases nor
elsewhere has the Court characterized aliens as First Amendment
expression. Yet it does no violence to the opinions to view them as
steps along this path. Functionally considered, porno movie houses
and adult bookstores create problems of associational dissonance
and concomitant neighborhood destabilization differing little, if any,
from those created by this volume's other aliens. Moreover, members
of the Court explicitly referred to the regimes challenged in the two
disputes as "aesthetic."[39] Finally, there are powerful reasons, grounded
in the First Amendment's purposes rather than in these opinions,
for concluding that some aliens, at least, are no less entitled to First
Amendment status than other forms of nonverbal expression already
accorded that status by the Court.

The Takings Issue

Earlier discussion of the Wagenfelds' neo–Italian Renaissance gas
station exposed a range of problems that lawyers group under the
"takings issue" label. The Fifth Amendment, as there noted, snaps
a line between government and property owners that government
may not cross unless it is prepared to pay for its intrusion. Where
to snap the line poses a legal question as enigmatic as any reviewed
in this volume. But the line must be drawn if the legal system is to
deal fairly with property owners and the community.[40]

Why Fairness?

Why should fairness be the compass rather than the Wagenfelds'
loss of freedom to deal with their property as they wish? The Fifth
Amendment speaks of "property," not fairness, after all, and what
is property but the owner's entitlement to use and profit from his
or her land? Wouldn't a plausible, indeed necessary, reading of the
amendment obligate the government to pay for its pilferage when-
ever it diminishes these entitlements?

Plausible, yes; necessary, no. As Fifth Amendment doctrine has
actually evolved, measures of this nature are seldom rebuffed as
takings unless they virtually annihilate private property's value—
and, often, not even then. Take the case of the unfortunate Mr.

Mugler and the costly brewery he built for beer guzzlers of the post–Civil War era. Did a state prohibition law that effectively closed his brewery "take" his property? No, ruled the United States Supreme Court, which concluded that the law's prohibitionist goals canceled Mugler's apparent entitlement to compensation.[41]

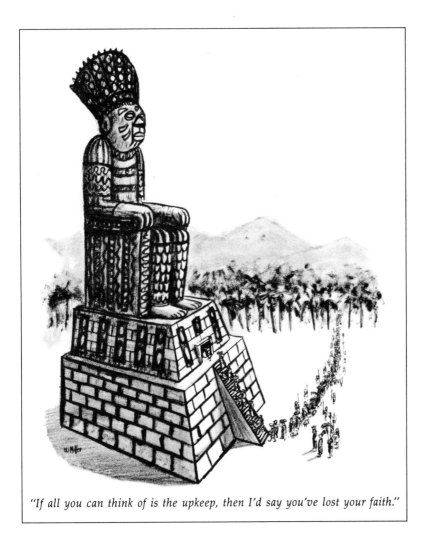

"If all you can think of is the upkeep, then I'd say you've lost your faith."

The Takings Issue

Enthusiasm for preserving icons, Rabbi Feigelstock and the Penn Central Company remind us, tends to be greater when they are someone else's property rather than our own. It's not so much that these icon owners have "lost their faith." They feel instead that the costs of preservation should be borne by the community at large, the beneficiary of preservation. But public restrictions on private property rights are commonplace in American life, particularly in the spheres of zoning and land use controls. The takings issue directly engages whether or not government must pay when it imposes these restrictions for aesthetics purposes.

At work in *Mugler* and subsequent decisions is the Court's effort to accommodate fairly the conflicting purposes served by the police and eminent domain powers. The police power worries about social welfare, not individual loss. Eminent domain cuts the other way in response to its charge to make individuals whole in the wake of public measures advancing social welfare at their expense. These contrary perspectives presage warfare if, as Justice Oliver Wendell Holmes observed, "all rights tend to declare themselves absolute to their logical extreme."[42] The takings issue is simply another title for this warfare.

As I read post-*Mugler* takings jurisprudence, courts labor to negotiate truces between these warring principles by reference to a third, which requires citizens to assume their "just share" of the common burden.[43] The government, this principle posits, must pay unless the challenged measure's purpose and the affected property's use are linked in a manner that persuades the court that the owner's burden has been fairly levied. It requires the government to respond plausibly to the question "Why me?" that property owners singled out for the burden inevitably ask. For example, laws forcing developers to donate land for parks within their subdivisions are not takings. The subdivision's construction creates the need for these parks, and the land's cost can be factored into the price paid by the developer's customers, for whom the parks are provided. A contrary result would obtain if the government required farmers, let us say, to surrender their land for an interstate highway system. There is no plausible linkage between building highways and growing corn.

Less abstract than the just share principle are two derivative considerations that judges emphasize in their takings opinions. One is the judge's assessment of the particular police power and eminent domain values at stake in the controversy. Some police power values appear to carry more weight than others. Preventing land uses that spread typhoid compels greater judicial sympathy than mandating flat roofs for houses in new subdivisions. So too do some eminent domain goals. Safeguarding landowners from the intrusion of strangers upon their property weighs more heavily in the judge's calculations than guaranteeing that speculators shoot the moon on risky land investments.

Unfortunately, we can never be sure for very long how particular values will score because the judicial calculus is a creature of era, prevailing social concerns, and, of course, the judge's own preferences. What better example than legal aesthetics itself? Recall the early judicial hostility to the venture reflected in one judge's sneer that "aesthetic considerations are a matter of luxury and indulgence rather than of necessity, and it is necessity alone which justifies the exercise of the police power to take private property without compensation."[44] I doubt that a judge could be found today who would openly espouse such a view.

Icons and Aliens

The other consideration influencing takings outcomes is the manner in which property rights are invaded. Four alternatives can be identified. The government might flatly move in and take over the property for a highway or some other public project. It might force property owners to allow strangers on their land, perhaps to distribute political leaflets in their shopping centers, or to provide legal advice to migrant workers on their farms. The government might require property owners to do something on their land at their own expense, as when it requires them to install fire sprinklers or pollution control devices. Conversely, it might preclude them from doing something on their land. Zoning works this way, for example, when it tells landowners that they may not build apartments in single-family districts or factories in residential districts.

Modern takings opinions regard these alternatives with a descending level of concern. Government-authorized occupations are per se takings, no matter how trivial their effects. A 1982 Supreme Court decision, for example, invalidated a New York State statute, enacted under the police power, that authorized cable television companies to locate their equipment atop apartment buildings. The Court agreed with a Manhattan landlord that the permanent occupation of only one-eighth of a cubic foot of her roof for this purpose was a taking. Even occupations of areas no "bigger than a breadbox"[45] demand compensation under this per se rule.

While measures denying landowners the right to exclude others from their property are not invalid per se, theirs is not an easy path either. A taking was found, for example, when the United States Corps of Engineers barred developers of Oahu's luxurious Hawaii Kai complex from excluding the public from boating in a marina around which the complex's poshest housing and shopping malls were constructed.[46] This opinion evidences the Court's grave concern over governmental tinkering with the property owner's right to exclude, an interest it has lauded as "one of the essential sticks in the bundle of rights that are commonly characterized as property."[47]

Considerably more lenient is judicial scrutiny of the remaining categories of measures—those obligating property owners either to do or to refrain from doing something on their land. Judges tend to be tougher on the first than on the second, perhaps because the second leaves the owner free to choose among a spectrum of non-forbidden actions while the first does not. Subject to this caveat, a taking is unlikely to be found in either instance unless such regulations wipe out what the Court has termed the owner's "investment-backed expectations."[48]

The Takings Issue and Legal Aesthetics

Understandably, the takings issue has given legal aesthetics the jitters from the very beginning. The just share principle's required linkage between the use of an aesthetically significant property—a

landmark, let us say—and the aesthetics measure's goal is not easily discernible. Can it really be said that landmarks are a "use" in the same sense in which hotels, fat-rendering plants, and miniature golf courses are "uses"?

Uses in the latter sense undoubtedly are sheltered by landmarks. New York City's Grand Central Terminal is a transportation use, for example, just as Nashville's Grand Ole Opry once was a recreational use. But landmarks are regulated on the basis of their community-defined *status,* not on the basis of owner-selected activities occurring within them. Viewed from this angle, it really is the community that is "using" the landmark, not the landmark's owner. Left to their own devices, for example, the Wagenfelds would have "used" their Greenwich Village site as a garden, not as a neo–Italian Renaissance landmark. Is it fair, then, to dump the costs of landmarks preservation upon them?

The issue becomes more troublesome still when the uses to which owners wish to convert their aesthetically significant properties are unobjectionable, as the Wagenfelds' proposed garden surely was. Land use controls, as traditionally conceived, seek to bar objectionable uses—the cement plant in the residential zone—not to preclude owners from using their property for benign purposes. True, the neo–Italian Renaissance gas station will be lost if replaced with a garden, and none of us, perhaps, wants to see that happen. But the Fifth Amendment's question is "Who should pay?" not "What do the rest of us think the Wagenfelds should do with their gas station?"

The intrusiveness of aesthetics programs has occasioned anxiety as well. None to my knowledge risks invalidation under the Supreme Court's per se ban against government-sponsored permanent occupations, with the possible exception of measures authorizing the attachment of plaques to the exteriors of designated landmarks. But they are vulnerable to greater perils than traditional land use regimes with respect to the other alternatives listed earlier.

Landmark programs, again, are illustrative. Designation of building *interiors* may impinge on the building owner's right to exclude, if such designations require owners to open their buildings to public view. Imposition of affirmative duties, such as the Wagenfelds' obligation to rescue their gas station from dereliction, may be perceived as unduly onerous. So too may bans upon demolition that leave owners with economically distressed buildings or require them to forfeit economic opportunities enjoyed by owners of neighboring nonlandmarked buildings.

Alert to these pitfalls, toilers in the legal aesthetics vineyard worked hard to reduce or, when appropriate, debunk the financial hardships that icon-preserving measures are claimed to cause. Programs were initiated allowing owners of diminutive landmarks to sell or transfer their excess development rights for use on sites not occupied by

icons. Larger, hence more profitable, buildings could be constructed on these sites, setting the stage for an exchange between landmark owner and developer and, not coincidentally, blunting the former's potential takings argument. A menu of federal, state, and local tax advantages was put in place that transformed many economically distressed landmarks into viable, and occasionally lucrative, properties.

The phrase "adaptive use" also entered the real estate industry's vocabulary as former warehouses, factories, and the like were restored and tenanted with boutiques, banks, law offices, and other financially vibrant businesses. Among the best known of these projects is San Francisco's Ghirardelli Square, once a collection of dilapidated chocolate factory buildings and now a magnet for tourists who flock to enjoy its shops, restaurants, and delightful view of the San Francisco Bay. Studies also began to appear that publicized preservation's benefits for neighborhoods designated as historic districts. Stressed were the findings that real estate values tend to stabilize or rise in these districts, while the incidence of crime diminishes.

Until 1978, however, there still was lacking a Supreme Court pronouncement that probed the various uncertainties the takings issue poses for aesthetics programs. With the Court's decision that year in *Penn Central Transportation Company v. City of New York*,[49] however, it became clear that aesthetics regimes would be viewed at least as favorably as traditional use regimes — and, quite possibly, more so.

The *Penn Central* case is an icon in its own right, destined as such because the Grand Central Terminal's owners challenged New York City's turn-down of a proposed Breuer tower atop their landmark on a variety of the grounds cited earlier. This was also a case in which huge sums were at stake: the city's action denied Penn Central some $15 to $20 million in the estimated capitalized value of a lease it had given to a developer for the space above the terminal. With powerhouse legal talent aiding both sides, a tortuous progression through three levels of New York State's court system as a preliminary, and the eyes of the legal world riveted upon it, this icon has invited endless discussion.

For our purposes, however, *Penn Central*'s basic message is clear: the Court will accord great weight to the welfare values advanced by legal aesthetics provided that the program in question has been carefully formulated and treats fairly with the icon owner's ability to earn a fair return on the property. Had the Court not elevated aesthetics values to this plane, I doubt that New York City would have prevailed. Unlike the New York courts, one of which had declared the ban a taking, the Supreme Court did not agonize at length over the "use" problem featured earlier in this section. It

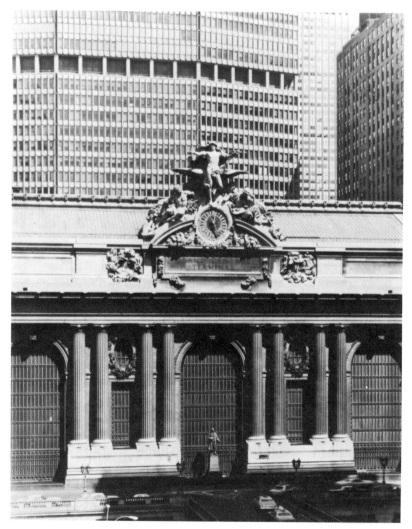

106

Grand Central Terminal: Past, Present, and (Aborted) Future

"Very few parcels of land in our largest cities . . . have not had as many as three different structures on them in the last hundred years," wrote Richard Nelson in 1955 in the *Appraisal Journal*. Competition to build ever larger, more functional buildings on centrally located sites imperils the retention of the building before. Nelson's rule of three would have applied to the Grand Central Terminal site as well but for New York City's landmarks law and the United States Supreme Court's *Penn Central* decision. The sequence begins with the Grand Central Depot, which occupied the terminal's site at the turn of the century (opposite page, top). It was followed in 1913 by the Grand Central Terminal (opposite page, bottom), undoubtedly an alien to those enamoured of the depot. In time, however, the terminal became the icon that, in turn, was threatened by a successor alien, the Breuer-designed fifty-two-story office tower, which would have filled the airspace above and required demolition of the terminal's Beaux Arts facade to the south.

chose instead to emphasize its concurrence with the city's claim that the building's preservation promised substantial benefits for its citizenry as a whole.

The opinion pleased preservationists on other fronts as well. The Court rejected Penn Central's claim that it was constitutionally entitled to the site's "highest and best use," a market standard that excludes the dampening effects of public regulation. In line with its reasoning in traditional land use disputes, the Court declared that the Fifth Amendment imposes the lesser standard of reasonable or fair return, which discounts the market standard in accordance with these effects. The city's action, it added, did not frustrate Penn Central's "investment backed expectations" because Penn Central "may continue to use the property precisely as it has been used for the past 65 years: as a railroad terminal containing office space and concessions." The Court also spoke favorably of the entitlement extended Penn Central by the city to transfer the site's unused development rights to other nearby sites in Penn Central's ownership.[50]

Penn Central was greeted with a sigh of relief by preservationists and other supporters of aesthetics initiatives. While I too am pleased that legal aesthetics can now take its rightful place alongside more traditional forms of land use regulation, I am troubled that *Penn Central* advances a conclusion grounded in reasoning both elliptical and simplistic, so typical of the modern genre of legal aesthetics opinions. Illustrative is its perfunctory treatment of the standards and use issues. Surely overstated is the claim, advanced by the Penn Central Company, that landmark designation is a standardless venture because it "is inevitably arbitrary or at least subjective [and, hence,] a matter of taste." But no less overstated is the Court's rejoinder: ". . . quite simply, there is no basis whatsoever for a conclusion that courts will have any greater difficulty identifying arbitrary . . . action in the context of landmark regulation than in the context of classic zoning or indeed in any other context."[51] This entire volume stands witness to the contrary.

Even more distressing is *Penn Central*'s failure to deal candidly with the use issue, an omission castigated by the three dissenting justices. Does the majority opinion reduce to the simplistic proposition that because preservation is such a "good thing," courts need not address the cost-allocation quandary that the use issue poses? If so, the Court has ignored Justice Holmes's caution that "all rights tend to declare themselves absolute to their logical extreme."

Or did the Court deliberately choose to leave the resolution of that issue to another day? This choice certainly would have been reasonable in view of a disastrous strategic ploy by the Penn Central Company. It had argued in the state courts, consistently with settled doctrine, that the tower ban was a taking because it precluded a fair economic return on the terminal property. At the Supreme Court

How Soon They Forget

No one can toil in the legal aesthetics vineyard for very long without chuckling about its many delicious ironies. Principal among them is the frequency with which the aliens of one generation become the icons of the next. An even more delightful twist came with a mid-1980s proposal to place a Postmodern Michael Graves addition atop Marcel Breuer's "New Brutalist" Whitney Museum in New York City. Breuer, of course, had earlier enraged preservationists with *his* proposal to place an International Style office tower atop the Beaux Arts Grand Central Terminal. The villain in that controversy, Breuer became the hero in the Whitney Museum spat because his building was now the icon threatened by Graves's alien.

level, however, the company chose not to pursue that argument, thereby effectively conceding what everyone thought (and many still think) the case was all about by acknowledging that it *could* earn a fair return despite the tower ban.[52]

As the Court construed the reformulated complaint, the company was now advancing a claim that virtually guaranteed defeat: namely, that the ban was a taking simply because it reduced the terminal property's value. Inexplicably discounted by the company was the Court's repeated rebuff of that claim in cases that go all the way back to its 1926 precedent establishing the constitutionality of classic zoning itself.[53] The extravagance of the substituted claim may have diverted the Court's attention from the worrisome use issue.

Predictably, some icon defenders have identified *Penn Central* with the first alternative and pushed for blatantly unfair aesthetics regimes. Illustrative is the regime devised by Rye, New York, purportedly to secure the preservation and restoration of a Colonial Revival mansion built in 1838, a carriage house added in 1912, and the twenty-two-acre grounds on which both are located.[54] To the

Aesthetics and Process Value

site's south is a neighborhood of expensive homes; to its east, a nature preserve bordering on Long Island Sound. The mansion had been used to headquarter a church group, but its upkeep proved so costly that the group sold the site to a developer in 1978. The developer offered to donate the mansion to the city, but the city declined, wary of the expenditures required for the mansion's restoration and maintenance.

A proposal envisaging the site's use for a low-rise office building failed to carry because the neighbors to the south didn't want a commercial use nearby. They were more welcome to a subsequent proposal for the site's residential development, but that alternative was torpedoed by the nature preserve's constituency, which wanted the mansion's grounds to remain forever wild. The city leaders then authored their own proposal in the form of a law obligating the developer to restore the mansion and carriage house exteriors, to convert their interiors to residential use, to establish a condominium regime requiring contributions to a permanent maintenance fund for the mansion and carriage house, and to provide a "view-way" by leaving undeveloped a substantial slice of the site between the mansion and the nature preserve to the east. Modification of the mansion and carriage house was required to be completed at an estimated cost in excess of $1 million before any housing units could be sold.

The law was a stroke of genius in its own way. The city and its preservationists would get their mansion and carriage house restored and permanently maintained at no cost to them. Cost-free too would be the addition to the adjacent nature preserve of the land below the view-way. The neighbors to the south would not have to suffer a commercial low rise nearby. And it was all to be done in the name of historic and environmental preservation. True, the developer would be forced to foot the bill for the package. Not to worry, the city's attorney advised. It's all legal under *Penn Central*.

Epilogue

The past floods us with ambivalent feelings. We embrace it as we seek to distance ourselves from it. We find continuity and roots in it, yes, but at the cost of frustrated innovation and autonomy. Our knowledge of the past frees us from having to reinvent the wheel, but it also inhibits us from replacing the wheel with something better. Moreover, there is not one past but many. And each of us has a past or, actually, many pasts successively created to suit our present. Each nation, social or ethnic group, or other community has its past as well. Like our individual pasts, these pasts are protean, acquiring and shedding images as the community's needs demand.

We cannot really know the past or retain the feelings or responses of those whose actions and artifacts created it. We can no more experience the eighteenth-century world by dining at a Colonial Williamsburg inn than can our waiter or waitress, however authentic their colonial garb. Colonial-style gasoline stations in Georgetown are wildly anachronistic, and nineteenth-century facades pasted on Foggy Bottom skyscrapers are dubious as well.

Ambivalence about retaining the physical residues of the past also pervades the writings of those who appreciate the power of icons to shape the symbolic environment. Lewis Mumford and Kevin Lynch, for example, caution against the tendency that we sometimes feel to convert icons into totems, much as a psychoanalyst might counsel his or her patients to avoid clinging to some idealized image of a parent in an obsessive attempt to forestall anxiety. Mumford appreciates that the city is the "best organ of memory man has yet created."[1] But he warns that insecurity in the face of change can cause us to prize icons that "are completely irrelevant to our beliefs and demands," advising that the "city itself, as a living environment, must not be condemned to serve the specialized purposes of the museum."[2]

Lynch views the environment as a "vast mnemonic system for the retention of group history and ideals."[3] Echoing Mumford, however, he counsels that "preservation of the environment [may] encapsulate some image of the past . . . that may in time prove to be mythical or irrelevant [because] preservation is not simply the saving of old things but the maintaining of a response to those things."[4]

He denies that legal aesthetics should concentrate exclusively on repelling aliens, urging that its purpose instead should be "to make visible the process of *change*" by safeguarding icons in some cases but cutting loose of them in others through "disposal of the irrelevant past," "creative . . . demolition," and the construction of "self-terminating environments."[5]

Architect-critics also chide excessive dependence upon familiar styles and structures. Aesthetic formalism, the basis upon which legal aesthetics is conventionally justified, is one of their chief targets.

"Leave it to the Landmarks Commission! They think of everything!"

The Allure of the Past

The allure of the past, treated humorously in this cartoon, undergirds the commercial success of Disneyland. Horse-drawn vehicles, Victorian architecture, Main Streets, and village greens speak to a simpler, more comfortable and familiar time. Or so we choose to view these artifacts and their era some number of generations later.

Consider Louis Sullivan's warning that "formulas are dangerous things. They are apt to prove the end of a genuine art, however hopeful they may be in the beginning to the individual. The formula of an art remains and becomes more and more dry, rigid, and shriveled with time while the spirit of the art escapes, and vanishes forever."[6] Robert Venturi and Le Corbusier enlarge Sullivan's warning into a frontal attack on government-imposed aesthetics regimes. In an effort to learn from Las Vegas, Venturi and his co-authors complain that "every community and state is appointing its design review

board to promote the architectural revolution of the last generation, and corrupts its members through rule-by-man rather than rule-by-law."[7] Le Corbusier found himself angrier still as he reflected upon the reflexive formalism of his native country: "The spirit of France is not rule-bound except in periods of lethargy and ossification. Today, when a new world is surging up under the impulse of technical miracles, the officials of the City of Light apply regulations. And soon there will be no lights in the City."[8]

Icons and Aliens: The Paste-on Solution

"Preservation," Kevin Lynch has observed, "is not simply the saving of old things but the maintaining of a response to those things." One has to wonder if his maxim is violated by design "solutions" in which nineteenth-century facades are pasted on twentieth-century office towers, as in the Penn Mutual Tower and the Pennsylvania Fire Insurance Company. The facade is saved, to be sure, but the response is humbled by the facade's incongruence with the massive tower enveloping it.

The transformation of icons into totems also draws the fire of these publicists. To Le Corbusier, "the American is janus: one face absorbed in the anxieties of adolescence, looking toward the troubles of his consciousness; the other face as solid as an Olympic victor's, looking toward an old world which at certain moments he believes he can dominate."[9] Sullivan goes a step further with his sullen insistence that "the Roman temple can no more exist in fact on Monroe Street, Chicago, USA than can Roman civilization exist there. Such a structure must of necessity be a simulcrum, a ghost."[10]

Judges must leave it to American society to wrestle with the choice between the familiar and the novel. They possess neither the power nor the wisdom to shape that choice. True, they must ensure that tradition-favoring choices taking form as aesthetics regimes respect process values. But these values concede great latitude to society in making the basic choice itself. It is enough that the choice serves some plausible social goal, even if it defeats other goals equally or

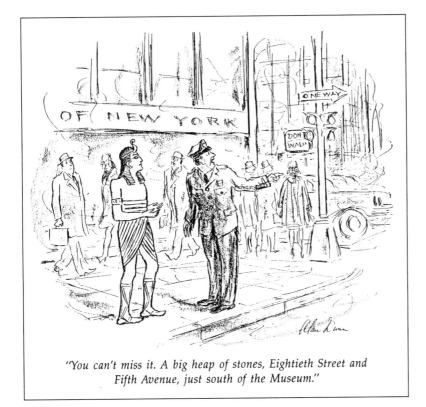

"You can't miss it. A big heap of stones, Eightieth Street and Fifth Avenue, just south of the Museum."

Roman Temples on Monroe Street, Chicago, U.S.A.

Louis Sullivan's impatience for banks done up as Roman temples led him to suggest that the bankers within wear togas. Here, we shift to the Egyptian, as the cartoonist teases an extension of Sullivan's suggestion. Our identity comprehends the past but is not completed by it. We must take care that icons become not barriers but bridges to whatever lies ahead.

more plausible. By alleviating the community's anxiety over the loss of its icons, tradition-favoring choices clearly meet this test. The courts have nothing to add. Nor would they if the choice favored innovation because its goals too would be plausible.

Lawmakers can enter more directly into the debate than judges, particularly as they conduct public hearings, draft legislation, and counsel with their constituencies, which will include both tradition-alists and innovators. But the influence of the lawmaker too is limited, as it should be. The choice for or against the familiar should be made by the culture at large, not by its legal system.

So, we must ask whether a tome on legal aesthetics is a useful thing. I suppose it isn't if we expect that it will make the choice for us. But it may indeed prove useful if we wish to make that choice with a more informed sense of its consequences for the legal system and, ultimately, for ourselves.

Notes

Preface

1. For an exhaustive listing of literature and judicial opinions espousing this reasoning, see John J. Costonis, "Law and Aesthetics: A Critique and a Reformulation of the Dilemmas," *Michigan Law Review 80* (1982): 355 and nn. 46, 56, 67, 83, 112, 113, 124, 128, and 134.

2. Donald Appleyard, "The Environment as a Symbol System," *Journal of American Institute Planners* 54 (1979): 152.

3. *Berman v. Parker,* 348 U.S. 26 (1954). *Berman's* pioneering role in sustaining the constitutional validity of legal aesthetics is discussed on pp. 23-26.

4. The problem of devising administrable standards for the Upper East Side Historic District, which was so designated in 1981, is further detailed on pp. 86-90.

5. See Costonis, "Law and Aesthetics," n. 1.

Chapter 1

1. William E. Geist, "Park Avenue Residents Want a New Deli to Go," *New York Times,* February 28, 1984, p. 1, col. 3.

2. Ibid.

3. William E. Geist, "Opening of Disputed Deli Hits Last-Minute Snag," *New York Times,* April 6, 1984, p. B16, col. 1.

4. Dick Cavett, "Mr. Choi, Subverter," *New York Times,* March 3, 1984, p. 33, col. 1 (Op Ed page).

5. Joseph W. Welsh, *New York Times,* March 10, 1984, sec. 1, p. 27, col. 4 (letter to the editor).

6. Cavett, "Mr. Choi, Subverter."

7. Geist, "Disputed Park Avenue Deli."

8. Paul Goldberger, "Rice Mansion Dispute Has Many Sides," *New York Times,* June 26, 1980, p. B2, col. 2.

9. Clyde Haberman, "Yeshiva Tries to Void Status as Landmark," *New York Times,* May 30, 1980, p. B1, col. 1, p. B2, col. 3.

10. Ibid., p. B1, col. 1.

11. Ibid., p. B2, col. 4.

12. Christopher S. Gray, "A West Side Sale Leads to Calls for Revision in the Zoning Law," *New York Times,* September 30, 1979, sec. 8, p. 1, col. 5.

13. Ibid.

14. Haberman, "Yeshiva Tries to Void Status as Landmark," p. B2, col. 4.

15. Ibid.

16. Alexander Baumgartner, *Reflections on Poetry,* K. Aschenbrenner and W. Hother, trans. (Berkeley: University of California Press, 1954).

17. Sigmund Freud, *Civilization and Its Discontents,* J. Strachey, trans. and ed. (New York: W. W. Norton, 1961), pp. 29-30.

18. John Dewey, *Art as Experience* (New York: G. P. Putnam's Sons, 1934), p. 229.

19. Robert H. Nelson, *Zoning and Property Rights* (Cambridge: MIT Press, 1977), pp. 45 (emphasis added), 16, 17.

20. Ibid., p. 21.

21. *People v. Stover,* 12 N.Y.2d 462, 471, 191 N.E.2d 272, 277 (Van Voohris, J. dissenting) *appeal dismissed,* 375 U.S. 42 (1963) (emphasis added).

22. Walter I. Firey, *Land Use in Central Boston* (Cambridge: Harvard University Press, 1947), p. 19.

23. Ibid., p. 34.

24. Lewis Mumford, *The Culture of Cities* (New York: Harcourt, Brace and Co., 1961), p. 5.

Chapter 2

1. For detailed documentation of the legal sources supporting the positions advanced in this chapter, see Costonis, "Law and Aesthetics."

2. *City of Passaic v. Paterson Bill Posting, Advertising & Sign Painting Co.,* 72 N.J.L. 267, 268 (1905).

3. *Curran Bill Posting & Distrib. Co. v. City of Denver,* 47 Colo. 221, 227, 107 P. 261, 264 (1910).

4. *City of Youngstown v. Kahn Blg. Co.,* 112 Ohio St. 654, 661-62, 148 N.E. 842, 844 (1925).

5. *St. Louis Gunning Advertising Co. v. City of St. Louis,* 235 Mo. 99, 145, 135 S.W. 929, 942 (1911).

6. *Berman v. Parker,* 348 U.S. 26 (1954) (citations omitted).

7. Norman Williams, *American Land Planning Law* (Chicago: Callahan and Co., 1974; supplement, 1981), vol. 1, sec. 11.02.

8. National Highway Beautification Act, 23 U.S.C. Secs. 136, 319 (1976 & Supp. III 1979).

9. National Historic Preservation Act of 1966, 16 U.S.C. Sec. 431 (1970).

10. See Tax Reform Act of 1976, Pub. Law 94-455 (1976), as amended by the Revenue Act of 1978, Pub. Law 95-600 (1978), the Tax Treatment Extension Act of 1980, Pub. Law 96-541 (1980), and the Economic Recovery Tax Act of 1981, Pub. Law 97-34 (1981).

11. National Environmental Policy Act of 1969, 42 U.S.C. Secs. 4321, 4331-35, 4341-47 (1976).

12. NEPA, 42 U.S.C. Secs. 4331(b)(2), 4331(b)(4), 4332(b) (1976).

13. *Penn Central Transportation Co. v. New York City,* 438 U.S. 104, 108 (1978).

14. See Charles F. Floyd and Peter Shedd, *Highway Beautification: The Environmental Movement's Greatest Failure* (Boulder: Westview Press, 1979).

15. Ada Louise Huxtable, "New York's Zoning Law Is Out of Bounds," *New York Times,* December 14, 1980, sec. 2, p. 41, col. 1.

16. Clifford L. Weaver and Richard F. Babcock, *City Zoning* (Chicago: Planners Press, 1979), p. 35.

17. Beverly Moss Spatt, *New York Times,* July 8, 1980, p. 16, col. 5 (letter to the editor).

18. Weaver and Babcock, *City Zoning,* p. 37.

19. Bernard J. Frieden, *The Environmental Protection Hustle* (Cambridge: MIT Press, 1979), p. 37.

20. *Southern Burlington County NAACP v. Mount Laurel Township,* 92 N.J. 158, 456 A.2d 390 (1983).

21. See "The Gentrification of the East Village," *New York Times,* September 2, 1983, sec. 8, p. 1, col. 1.

22. Ibid.

23. Ibid.

24. Appleyard, "The Environment as a Symbol System."

25. *New York Times,* April 2, 1984, p. 27, col. 3.

26. Ibid.

27. See *Gumley v. Board of Selectmen,* 371 Mass. 718, 722, 358 N.E.2d 1011, 1014 (1977) ("incongruity"); *Town of Deering ex rel. Bittenbender v. Tibbets,* 105 N.H. 481, 485, 202 A.2d 232, 235 (1964) ("atmosphere").

28. *Vickers v. Gloucester Township,* 37 N.J.2d 232, 243, 181 A.2d 129, 142 (1962), quoting Norman Williams, "Planning and Democratic Living," *Law and Contemporary Problems* 20 (1955): 317, 349-50.

Chapter 3

1. Kevin Lynch, *The Image of the City* (Cambridge: MIT Press, 1960), p. 126.

2. Kevin Lynch, *What Time Is This Place?* (Cambridge: MIT Press, 1972), p. 40.

3. Norma Evenson, *Paris: A Century of Change, 1878-1978* (New Haven: Yale University Press, 1979), p. 124.

4. Marc Fried, "Grieving for a Lost Home," in *People and Buildings,* Robert Gutman, ed. (New York: Basic Books, 1972), pp. 229, 230.

5. "They Call It Fort Apache; We Call It Home," *Village Voice,* February 11, 1981, p. 1, col. 1.

6. Appleyard, "The Environment as Symbol System," p. 151.

7. See A. Craig Copetas, "Trashtime for Zurich," *Esquire,* July 1981, pp. 44, 50.

8. Evenson, *Paris,* p. 69, n. 3 (quoting Menebrea, "Les Enseignements du Vieux Pont Neuf," *Urbanisme,* November-December 1932, p. 266).

9. Christopher W. Alexander, *Notes on the Synthesis of Form* (Cambridge: Harvard University Press, 1964), p. 26.

10. Jane Jacobs, *The Death and Life of Great American Cities* (Westminister: Modern Library, 1961), pp. 372-73.

11. Baumgartner, *Reflections on Poetry.*

12. Edmund Burke, *A Philosophical Inquiry into the Origin of Our Ideas of the Sublime and Beautiful* (2d ed.; London: R. and J. Dodsley, 1759), p. 210.

13. See *People v. Stover,* 12 N.Y.2d 462, 468, 191 N.E.2d 272, 276, *appeal dismissed,* 375 U.S. 42 (1963).

14. Susanne K. Langer, *Feeling and Form* (New York: Charles Scribner's Son, 1953), p. 59.

15. Grady Clay, *Close-Up: How to Read the American City* (New York: Praeger, 1973), p. 17.

16. See Monroe Beardsley, *Aesthetics from Classical Greece to the Present* (New York: Macmillan, 1966), p. 146 (ascribing this quotation to George de Scudery).

17. As quoted in Evenson, *Paris,* p. 361.

18. Albrecht Dürer, "Introduction" (to an unfinished work variously titled *Teaching in Painting, A Dish for Young Painters, Salus 1512,* and *Salus 1513*), in *The Writings of Albrecht Dürer,* William Martin Conway, trans. (New York: Philosophical Library, 1958), p. 179.

19. Dewey, *Art as Experience,* p. 311.

20. Ada Louise Huxtable, *Kicked a Building Lately?* (New York: Time Books, 1976), p. 222.

21. Mumford, *The Culture of Cities*, p. 438.

22. Camillo Sitte, *The Art of Building Cities*, C. Stewart, trans. (New York: Reinhold Publishing, 1945), p. 32.

23. Paul Goldberger, *The City Observed* (New York: Random House, 1979), p. xiii.

24. Le Corbusier, *When the Cathedrals Were White*, Francis E. Hyslop, Jr., trans. (New York: Harcourt, Brace and Co., 1947), p. 50.

25. Quoted in Christopher Tunnard and Henry H. Reed, *American Skyline: The Growth and Form of Our Cities and Towns* (New York: New American Library, 1955), p. 131.

26. Evenson, *Paris*, p. 124.

27. Roger Fry, *Vision and Design* (London: Chatto and Windus, 1920), pp. 292-93.

28. Langer, *Feeling and Form*, p. 406.

29. Louis Sullivan, *Kindergarten Chats and Other Writings* (New York: Wittenborn, Schultz, 1947), p. 185.

30. Siegfried Giedion, *Space, Time, and Architecture* (Cambridge: Harvard University Press, 1941), p. 583.

31. Williams, *American Land Planning Law*, vol. 3, sec. 71A.06 .

32. Walter Kidney, *The Architecture of Choice: Eclecticism in America, 1880-1930* (New York: George Braziller, 1974), p. 2.

33. Rudolph Arnheim, *Visual Thinking* (Berkeley: University of California Press, 1969), p. 37.

34. See *United States v. County Board*, 487 F. Supp. 137, 143 (E.D. Va. 1979).

35. Ibid., 145.

Chapter 4

1. The quote is attributed to Harvard Law School constitutionalist T. R. Powell.

2. *New York Times*, April 27, 1985, p. 36, col. 1.

3. "Dollars v. History on a Fifth Avenue Block," *New York Times*, February 14, 1985, p. 1, col. 1.

4. Ibid.

5. "Landmarking Needs a Review" (editorial), *New York Times*, March 9, 1985, p. 22, col. 1.

6. "Man to Defend His Unmown Lawn in Court," *New York Times*, September 16, 1984, p. 50, col. 1.

7. Ibid.

8. "The Saga of a Landmark Gas Station," *New York Times*, November 1, 1984, p. 1, col. 1.

9. John Keats, "Ode on a Grecian Urn," in *The Poems of John Keats*, Jack Stillinger, ed. (Cambridge: Harvard University Press, 1978), pp. 372-73.

10. Mumford, *The Culture of Cities*, p. 434.

11. See John J. Costonis, *Space Adrift: Landmark Preservation and the Marketplace* (Urbana: University of Illinois Press, 1974), chap. 3.

12. Firey, *Land Use in Central Boston*.

13. *Commissioner v. Benenson*, 329 A.2d 437, 441-42 (D.C. 1974).

14. *Sun Oil Co. v. City of Madison Heights*, 41 Mich. App. 47, 53-54, 199 N.W.2d 525, 529 (1972). For a collection of other judicial opinions reflecting a view of legal aesthetics' rationale more compatible with that offered in this volume, see Costonis, "Law and Aesthetics," p. 355 and nn. 80, 119, 140, 166, 177, 208, 231, 254, 286, 292, 306, 381.

15. "A Federal Preservation Agenda for the 80's," *Preservation News*, October 1980, p. 7.

16. Sullivan, *Kindergarten Chats*, pp. 139, 50.

17. *General Outdoor Advertising Co. v. Department of Public Works*, 289 Mass. 149, 182, 193 N.E. 799, 814 (1935).

18. *United Advertising Corp. v. Borough of Metuchen*, 42 N.J. 1, 5, 198 A.2d 447, 449 (1964).

19. Giorgio Cavaglieri, "Regarding the Designation of [the] Upper East Side District" (open letter, June 19, 1979), pp. 1, 2.

20. Paul Goldberger, "Debate over Proposed 71st Street Tower," *New York Times*, November 10, 1981, p. 88, col. 3.

21. *Terminiello v. City of Chicago*, 337 U.S. 1, 4 (1949).

22. See *Schad v. Borough of Mount Ephraim*, 101 S. Ct. 2176, 2182-83 (1981).

23. *Spence v. Washington*, 418 U.S. 405, 410-11 (1973).

24. Sullivan, *Kindergarten Chats*, p. 184.

25. Langer, *Feeling and Form*, p. 96.

26. *Cohen v. California*, 403 U.S. 15, 26 (1971).

27. See *Doran v. Salem Inn, Inc.*, 422 U.S. 922, 932-33 (1975); *California v. LaRue*, 409 U.S. 109, 118-19 (1972).

28. See *Tinker v. Des Moines Independent School District*, 393 U.S. 503, 505-6 (1969).

29. See *Spence v. Washington*, 418 U.S. 405, 410-11 (1973).

30. See *Cohen v. California*, 403 U.S. 15 (1971).

31. *Terminiello v. City of Chicago*, 337 U.S. 1, 4 (1949).

32. *Schad v. Borough of Mount Ephraim*, 101 S. Ct. 2176, 2182-83 (1981).

33. New York City Charter and Administrative Code Ann. chap. 8-A, sec. 207-1.0(h) (Williams 1976).

34. *Young v. American Mini Theaters, Inc.*, 427 U.S. 50, 70 (1976) (Stevens, J.).

35. *Village of Belle Terre v. Booras*, 416 U.S. 19 (1974) (Marshall, J., dissenting).

36. *Young v. American Mini Theatres*, 427 U.S. 50 (1976).

37. *Schad v. Borough of Mount Ephraim*, 101 S. Ct. 2176 (1981).

38. Ibid., 2190 (Stevens, J., concurring).

39. See *Schad v. Borough of Mount Ephraim*, 101 S. Ct. 2176, 2184, 2187, 2188-89, 2192.

40. For a more technical discussion of the takings issue with supporting citations for the views advanced in the text, see John J. Costonis, "Presumptive and Per Se Takings," *N.Y.U. Law Review* 58 (1983): 465.

41. See *Mugler v. Kansas*, 123 U.S. 623 (1887).

42. *Hudson County Water Co. v. McCarter*, 209 U.S. 349, 355 (1908).

43. Among the better-known statements of the "just share" principle is that expressed in *Monongahela Navigation Co. v. United States*, 148 U.S. 312, 325 (1893): "[The takings clause] prevents the public from loading up on one individual more than his just share of the burdens of government, and says that when he surrenders to the public something more and different from that which is exacted from other members of the public, a full and just equivalent shall be returned to him."

44. *City of Passaic v. Patterson Bill Posting, Advertising and Sign Painting Co.*, 72 N.J.L. 267, 268 (1905).

45. *Loretto v. Teleprompter Manhattan CATV Co.*, 102 S. Ct. 3164, 3177 n. 16 (1982).

46. *Kaiser Aetna v. United States*, 444 U.S. 164 (1979).

47. *Loretto v. Teleprompter Manhattan CATV Co.*, 102 S. Ct. 3164, 3167 (1982).

48. *Penn Central Transportation Company v. City of New York*, 438 U.S. 104, 124 (1978).

49. Ibid., 104.

50. Ibid., 136, 137.

51. Ibid., 133.

52. See ibid., 130 nn. 24, 26.

53. *Village of Euclid v. Ambler Realty Co.*, 272 U.S. 365 (1926).

54. The author was retained on behalf of the developer in the early stages of a lawsuit initiated by the developer to challenge on takings and other grounds the Rye ordinance discussed later in the text.

Epilogue

1. Mumford, *The City in History*, p. 562.

2. Mumford, *The Culture of Cities*, pp. 438, 446.

3. Lynch, *The Image of the City*, p. 126.

4. Lynch, *What Time Is This Place?*, p. 53.

5. Ibid., pp. 57 (emphasis added), 116, 57, 112.

6. Sullivan, *Kindergarten Chats*, p. 139.

7. Robert Venturi, Denise Scott Brown, and Steven Izenour, *Learning from Las Vegas* (Cambridge: MIT Press, 1972), p. 148.

8. Le Corbusier, *When the Cathedrals Were White*, p. 20.

9. Ibid., 14.

10. Sullivan, *Kindergarten Chats*, p. 39.

Index

Illustration Credits

A Note on the Author

JOHN J. COSTONIS is dean of the Vanderbilt Law School and Milton Underwood Professor of Free Enterprise. Previously, he taught in the urban design, historic preservation, and property fields on the law faculties of New York University and the Universities of California (Berkeley), Pennsylvania, and Illinois. A frequent contributor of essays on design and land use topics to legal and lay publications, Costonis is also the author of *Space Adrift: Landmark Preservation and the Marketplace*, a seminal study of the use of incentive zoning to finance the preservation of endangered urban landmarks. His planning and design research has been cited for its distinction by the American Planning Association and other professional organizations, and his work in the areas of incentive zoning and legal aesthetics has been supported by the National Endowment for the Arts. Costonis has also served as a consultant or panelist on housing, design, or historic preservation issues for the United States Departments of the Interior and of Housing and Urban Development, the President's Advisory Council on Historic Preservation, the National Endowment for the Arts, and the National Trust for Historic Preservation.